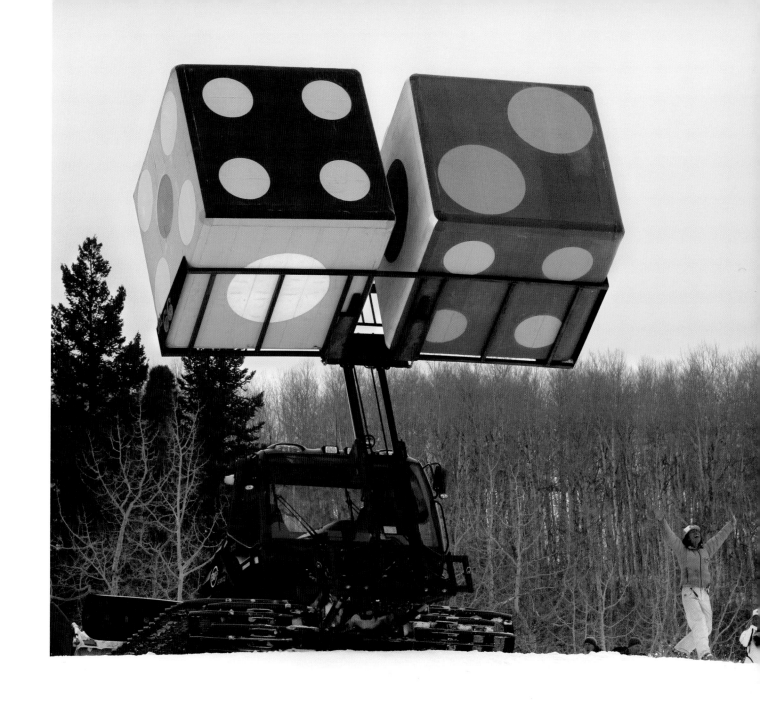

ART IN UNEXPECTED PLACES

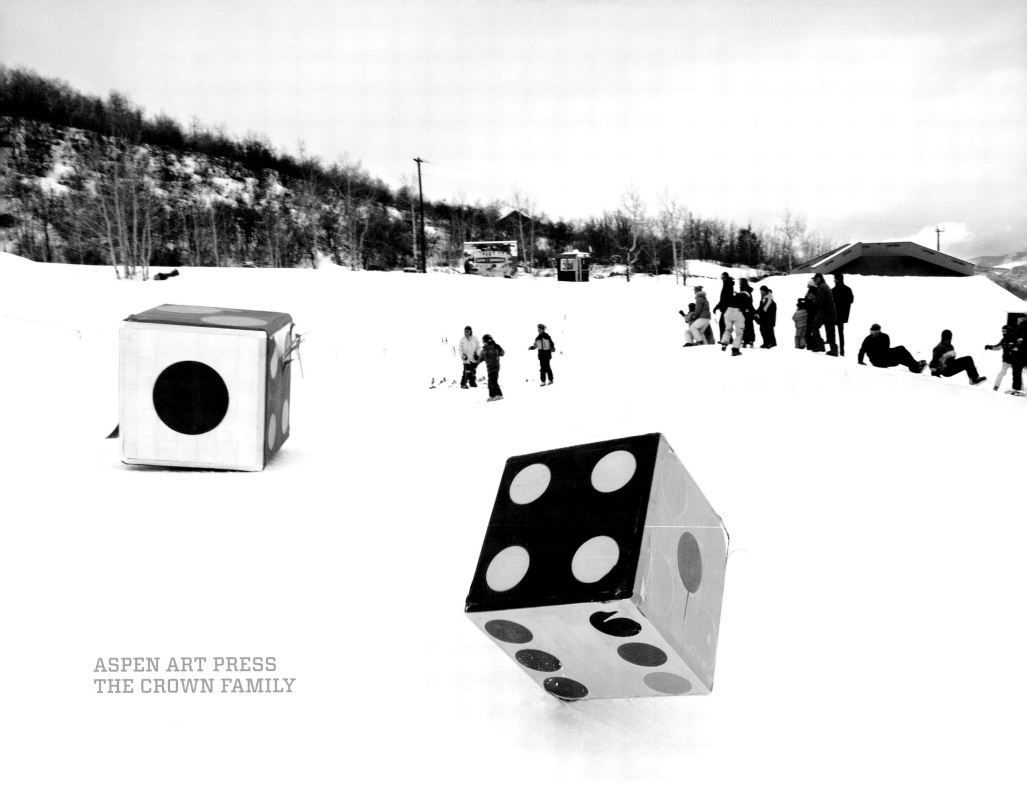

ASPEN ART PRESS
THE CROWN FAMILY

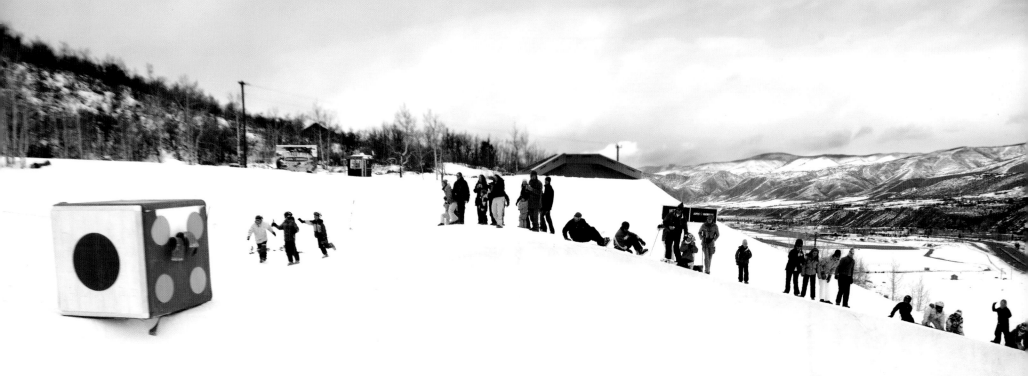

ART IN UNEXPECTED PLACES

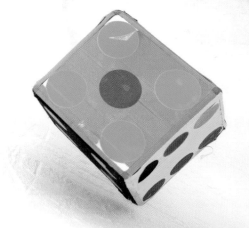

THE ASPEN ART MUSEUM /
ASPEN SKIING COMPANY COLLABORATION

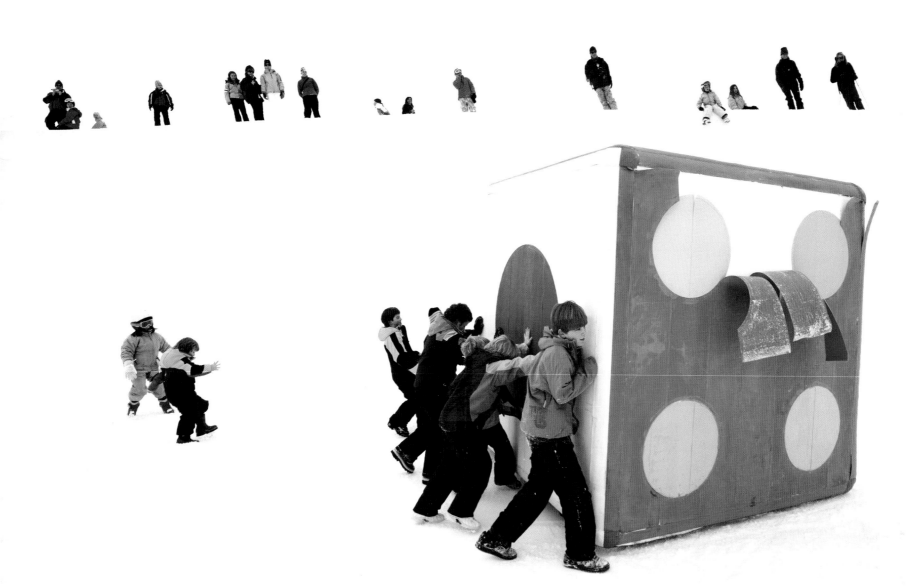

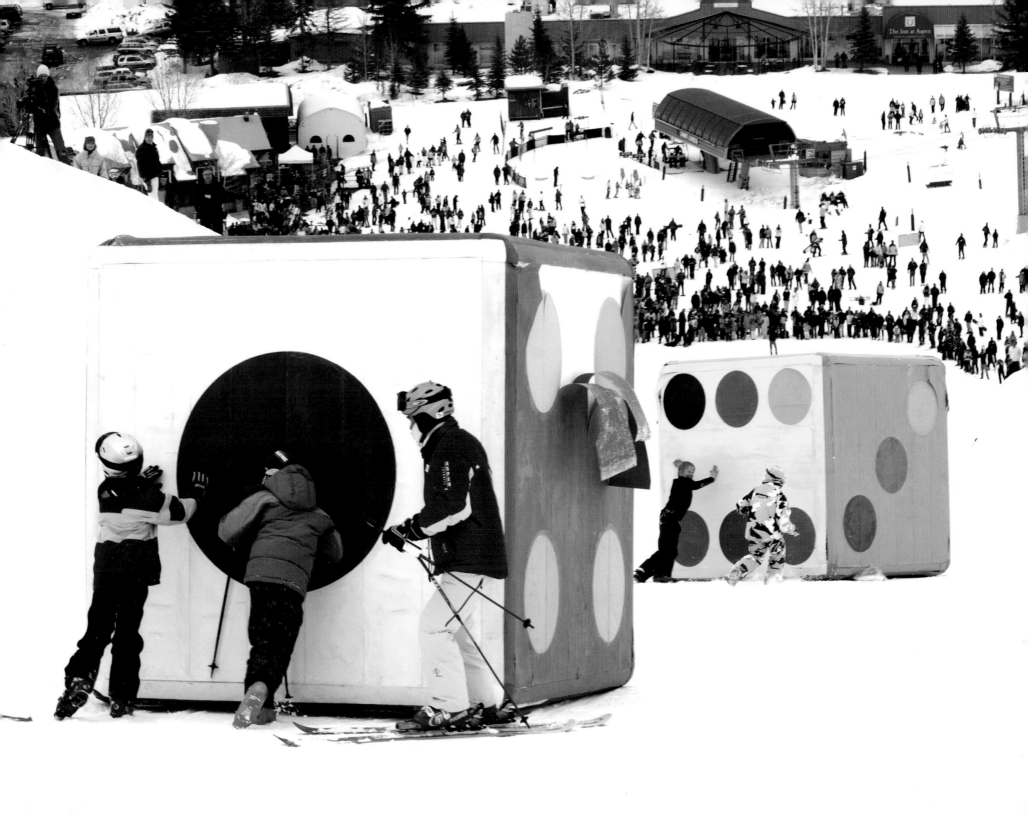

Cover, pages 1–6:
Yutaka Sone, *Mt. 66*, 2006
Performance at
Buttermilk Mountain, Aspen

CONTENTS

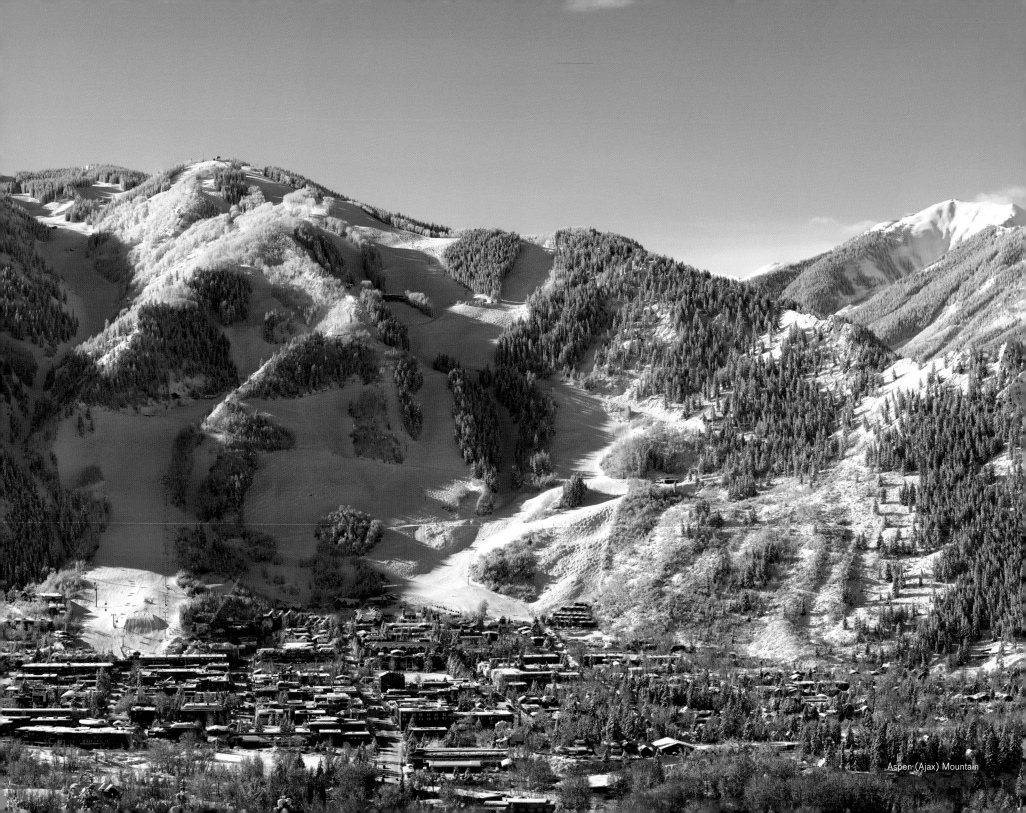

Aspen (Ajax) Mountain

UNEXPECTED ENGAGEMENT, UNEXPECTED RESULTS

What does art have to do with the skiing business . . . or any business? Chicago businessman Walter Paepcke, the founder of the Aspen Skiing Company, was one of the first industrialists to answer that question. He used renowned artists such as Bauhaus designer Hebert Bayer to create a brand and to communicate emotionally with customers. This linkage between design and identity was a concept on the cutting edge in the middle of the twentieth century. Paepcke was also ahead of his time when he founded the Aspen Skiing Company in the context of a broad community vision for Aspen. He labeled that vision: The Aspen Idea. He recognized that Colorado's upper Roaring Fork Valley was a special place — a near-utopian environment where people could experience renewal of the whole person: mind, body, and spirit. Central to Paepcke's vision was the role of the arts. He firmly believed that culture and the life of the mind were as important to one's well-being as recreation, financial security, or physical health. Aspen has remained steadfast in its pursuit of those original values; that is why it remains such a vibrant and attractive community. Our cultural institutions are world class — they are extraordinary for a remote mountain town nestled in a box canyon.

Three generations of our family have been coming to Aspen since the early 1970s. While the ownership of the Aspen Skiing Company is our most visible presence, we are involved in a wide array of businesses, partnerships, and philanthropic endeavors in the Roaring Fork Valley. We are privileged to be a part of such a special community; our support of the arts and the cultural life of Aspen is at the forefront of our participation in this special place.

This book commemorates an innovative collaboration between the Aspen Skiing Company and Aspen's premier arts institution: the Aspen Art Museum. In 2005, AAM Director and Chief Curator Heidi Zuckerman Jacobson arrived in Aspen with a fresh outlook on the museum's constituency and on Aspen's possibilities. She noticed the white paper lift tickets dangling off ski jackets throughout town. To Heidi these utilitarian, two-by-three inch cards were an opportunity. She didn't see them as admission tickets, she saw them as blank canvases. Heidi approached the Aspen Skiing Company with her idea: we should invite contemporary artists to participate directly in the cultural life of the valley by creating new works for the lift tickets. Ever since, skiers and snowboarders on Aspen's four mountains have used ski passes that display unique, contemporary, wearable art.

Our collaborations with the Aspen Art Museum align with our family's overall approach to philanthropy and civic life. And what better way to make art accessible and memorable than to find it in unexpected places? Like Walter Paepcke, his wife Elizabeth, and countless others before us, we are energized and nurtured by the majesty of Aspen. The dramatic mountains, the rushing rivers, and the abundance of wildlife provide beauty and recreation. These features make Aspen a cultural magnet and a source of inspiration, creativity, and intellectual opportunity. Like a trek into the mountains or a run down Ajax, it is impossible to know exactly how the day will go or what the next turn will reveal.

One of the most exciting concepts of contemporary art is this idea of spontaneity and surprise. Conceptual art, public art, or sound installations such as Susan Philipsz's *White Winter Hymnal* (see pp. 111–17) can appear in unexpected places and allow the viewer to see or hear things in new ways. This approach invites the public to connect with the work in a fundamentally different manner — one that is vibrant, immediate, and free of the perceived stuffiness of 'formal art in formal settings.' The Aspen Skiing Company and Aspen Art Museum are committed to this idea of making memorable interaction a part of daily life.

Our family's support of this project is grounded in the belief that the benefits of art are universal — cutting across class, race, and politics. If we provide engaging artistic interactions, people will have a more complete and gratifying experience. The element of surprise, delight, and sometimes provocation can make these moments transformational. At the very least, we hope they create a lasting connection and vivid reminder — not just of a vacation or a day in the mountains — but of the importance of art in our lives.

Here is an example of the many art experiences you'll encounter in this book. For one of our collaborative projects, the Aspen Art Museum and the Aspen Skiing Company invited artist Yutaka Sone to stage a performance (see pp. 1–6) on our halfpipe on Buttermilk Mountain. When his large fabric dice stalled, instead of tumbling down the mountain as planned, spectators became part of the performance. Children in the crowd started sliding down the sides of the halfpipe, pushing the dice further and ripping the sides off to create their own sleds. The result of this art show could not have been choreographed any better; spontaneity and engagement ruled the day.

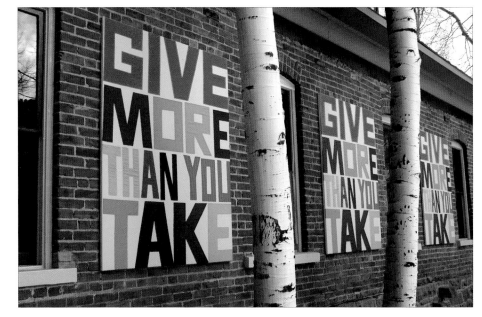

Jim Hodges, *give three times*, 2009
Installation view, Aspen Art Museum

A quite different project emerged from our research into and admiration for the work of Walter Niedermayr, the internationally acclaimed photographer. Niedermayr's startling and complex images of landscapes and alpine scenery have achieved worldwide recognition, but he had never been to the Rocky Mountains. His visits to the valley and *The Aspen Series* (2009) of photographs that resulted present familiar locations with a dramatically different interpretation of space, proportion, and human presence.

Our collaborations with the Aspen Art Museum invite participation and engagement between Aspen's beautiful landscape, the artwork, and our guests. Like Aspen itself—a daring idea from the beginning—our unconventional partnership has led to unexpected results. As you'll see throughout this book, The Aspen Idea is alive and well—at the very core of how the we run the Aspen Skiing Company some 64 years after its founding.

As a family, we have grown and become more diverse. We are now four generations along as an enterprise and reside across the country—but our shared love of Aspen and skiing has given grandparents, parents, and children (now mostly young adults) a vital common ground. Our family values are important and can be summed up most succinctly by something Jim Hodges, another lift-ticket artist, expressed through the maxim: "Give More Than You Take." For us that concept presents both a goal and a challenge—much like the preservation of the ecosystem that is the Roaring Fork watershed. Paepcke got it right: mind, body, and spirit are inextricably interlinked; happiness requires wholeness. Recognizing these relationships in nature, in communities, in culture, and in people creates possibilities. Perhaps more importantly they can offer far-reaching solutions, not only for individuals but for society. That is good business and good citizenship. For our family, this is what it means to "Give More Than You Take."

PAULA AND JIM CROWN

Gondola on Ajax Mountain, Aspen

THE SKI DAY, DISRUPTED

Michael Miracle

A ski town in winter moves to a predictable rhythm. Not surprisingly, it's one largely defined by skiing and snowboarding. People are either sliding downhill for much of the day, for part of the day, or plotting a way to do one of the two, biding their time until they can make it to the mountain, if even for a single run. Or at least the ubiquity of skiing-related chatter around Aspen can make it feel that way. On the most memorable ski days, whether for copious powder, favorable temperatures, abundant blue skies, or some combination thereof, conversations tend toward recounting conditions on the slopes, with knowing, smiling faces reveling in the memory of the day.

Yet no aspect of winter defines the season more than winter itself. Shorter days, lower temperatures, and lots of snow narrow the experience in town relative to summer. A five-month blanket of white covers the landscape; there's a lot less to do. Folks hunker down and move more purposefully to and fro. As a result, blinders of sorts can go up, turning the day into something navigated as if by rote: bundle up, ski, eat, sleep, repeat. (Full-time Aspenites squeeze work in there, too.) It's predictability at its most blissful, the routine made somehow exhilarating, if at times a bit chilly.

Though, occasionally, a disruption comes along. And when an event or encounter does manage to nudge a person off of the worn path of experience, its effect can be profound. On the mountain, a disruption might come as simply as the diamond twinkling of sunlight hitting the snow — an aesthetic reminder that skiing is as much a slow dance with nature as it is a high-energy one with

gravity. Or perhaps it arrives as the chancing upon a hidden Aspen Mountain shrine, whether pictures of Marilyn Monroe adorning a handful of trees, or a two-person swing — the Valentine's Shrine — that, swung and dismounted just right, offers a tandem, flying start to Hyrup's Run. Still, as entertaining and unexpected as those disruptions might be, neither yanks a skier's psyche too firmly out of the context of the ski day. And that's not necessarily a bad thing. They depart the snow-sliding experience as fluidly as they arrived, intriguing road signs on a white highway leading downhill.

But some ski-day disruptions do provoke and linger. They sneak into the experience in less-expected places and forms, and stick in the mind even more as a result. During the 2008–09 ski season, one such disruption was handed to every skier and snowboarder who purchased an Aspen/Snowmass lift ticket. (And that means thousands of people.) Printed on one side of that most commercial of ski-area necessities was a Jim Hodges–designed imperative, writ in colorful block letters against a bright yellow backdrop: Give More Than You Take.

For a sport synonymous with exclusivity at the resort whose name is among the ski world's most recognizable luxury brands, Hodges's work served not only as a disruption, it served as a fairly audacious one. The cheerfulness of its color palette only added to its subversiveness. Glancing at *Give More Than You Take* in a gondola car full of strangers teased out stereotypes and prejudices — surely the woman clad in head-to-toe Prada skiwear is taking more than she gives — which, in turn, if the thinker really thought, led to a

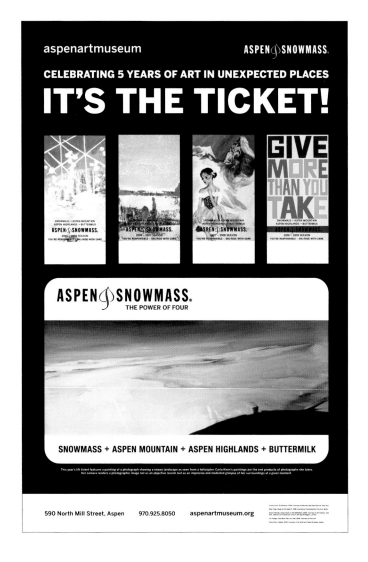

realization of the dangers of so quickly making such assumptions. Could anyone ensconced in a gondola at Aspen Mountain really be giving more than he takes? A skier could thus end his lift ride thinking not about the run he was about to ski but of where he fit in the grand scheme of fairness and inequality. Aspen Mountain's Snoopy shrine, for all its cuteness, has never quite had that effect.

Hodges's work represented the fourth consecutive season that the Aspen Art Museum commissioned art for the Aspen Skiing Company's lift ticket. Others were less aggressively provocative, using the context of skiing in more traditionally artistic ways, whether Karen Kilimnik's fairy tale-ish *Gelsey Stuck on the Matterhorn* (for the 2007–08 season), the abstract Swedish landscape of Carla Klein's *Untitled* (the 2009–10 season), or Yutaka Sone's *Ski Madonna* (2005–06), which put the viewer on skis, pursuing the work's title subject down the hill. (And for those who've ever skied behind the woman who served as Sone's inspiration—über skier and mountaineer Christie Sauer Mahon—that implied pursuit would have proved futile.)

One of the great aftereffects of the purchase of any of the lift tickets—and even more so, the collection of all of them—has been their ability to serve as markers in time. Skiers still in possession of Kilimnik's ticket might be reminded of the snowiest December in Aspen's history. Those with Mamma Andersson's *Sleeping Standing Up* (for the 2010–11 season) could very well have used it to ski Aspen Mountain during the Food & Wine Classic in June—a rare and memorable occurrence. And holding onto lift tickets is indeed quite common among lifelong skiers. Season passes in particular tend to make for obsessively squirreled-away keepsakes, the photos of their owner offering a time-lapse view of an aging skier through the years.

When he set up a photo booth during Aspen Skiing Company's 2009 Spring Jam celebration at various spots in Aspen and Snowmass as part of his

Patterson Beckwith (right) at the 2009 Bud Light Spring Jam

Portrait Studio project, Patterson Beckwith, who had conducted the same picture-taking endeavor at art fairs and exhibitions around the United States and Europe, may not have realized he was tapping into an annual ski-town rite of passage. But he did, and his booths went beyond the look-at-the-camera-and-we're-done formality of the season-pass photo. Fake snow encouraged jocularity, multiple exposures allowed subjects to pose with themselves, and the festivities of Spring Jam loosened inhibitions considerably — quite the opposite of the too-long-in-line impatience that typically precedes mugging for a season pass. The results were funny, touching, even goofy. They captured a snapshot of skiers and snowboarders reveling in their sports' equivalent of an after-party, a snow-birthed bacchanal that took up a whole corner of town. And as with all spontaneous sessions in a photo booth, participants walked away with an image in hand, generating a sort of instant nostalgia, the festive spontaneity having been transformed into a physical memento.

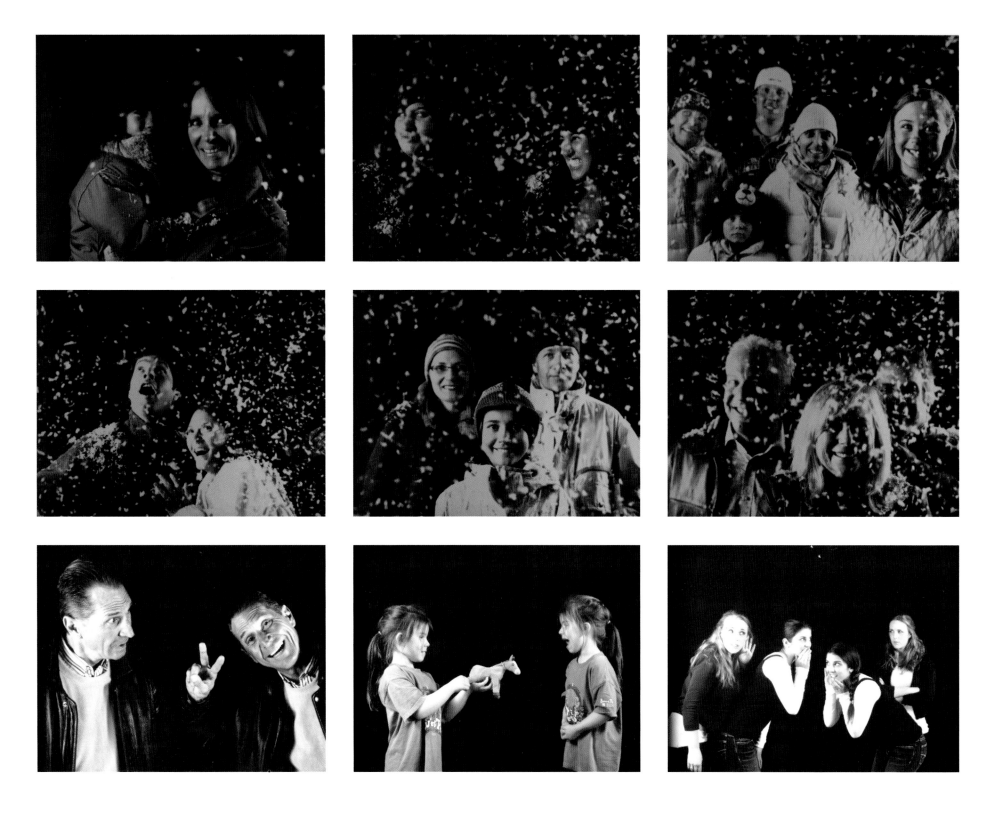

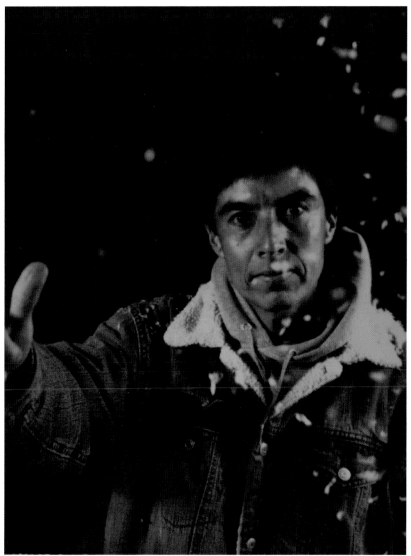

Patterson Beckwith, stills from *Portrait Studio*, 2009

But if Beckwith's *Portrait Studio* hinted at memory, Peter Doig's work mined the sentiment more pointedly. The title alone of Doig's 2006–07 lift-ticket art—*Study for Olin Mark IV* (1996)—coaxed remembrances of a classic orange ski from the 1970s, which allowed the art itself to tickle even deeper recollections from the viewer: a coveted pair of skis, a dreamy instructor from a family ski trip, a first lift ride alone. And by screening an evening of vintage ski movies—two from the 1970s and one, *Der Weisse Rausch*, from 1931, believed to be among one of ski cinema's oldest—Doig briefly reminded a skiing public accustomed to the inanities of paint-by-numbers ski movies that the genre, and thus the sport, once approached its celluloid treatment more thoughtfully.

Jennifer West, on the other hand, for her interpretation of the ski film, took present-day snow-sliding at its most aggressive and turned it on its head. In having skiers and snowboarders ride over, stomp on, and otherwise intentionally deface strips of film for her *Shred the Gnar Full Moon Film Noir* (2010), West harnessed twenty-first-century skiing and snowboarding's caustic side—the rail-sliding, half-piping, X Games culture that for older skiers is often the equivalent of a quiet day despoiled by heavy metal. To further stamp the film with youthful defiance, she took it hot tubbing and rubbed it with K-Y Jelly before screening it.

Though West's finished presentation of a film of the moon scarred by youth culture may have been interpreted as one would expect—the young saw the fingerprints of their exuberance as something positive, the old perhaps less so—it did cause some viewers to break ranks. Youth culture has always injected itself into the sport of skiing as a generational disruption, and it's been confronted by an institutional, ageist pushback every time. The arrival of snowboarding (and its subsequent effects on skiing) is surely the biggest cultural disruption the ski world has ever encountered; three resorts in the United

Production still from Jennifer West, *Shred the Gnar Full Moon Film Noir*, 2010

States still don't allow it. That West thought to leverage known ski-world disruptions to create a wholly original artistic one deserves a bravo. She allowed the activity on the hill to be inscribed on the artwork.

Both Beckwith's photo booth and West's screening of marred film had been devices and methods used by the artists before. But the contextual inclusion of skiing and snowboarding deepened the works' impacts considerably. Yutaka Sone, too, had previously used the principal element—the tossing of giant dice—of his 2006 performance piece, *Mt. 66*, before he did so at Buttermilk,

Yutaka Sone, *Mt. 66*, 2006. Performance at Buttermilk Mountain, Aspen

where he sent a pair tumbling down that mountain's halfpipe. What that new framework added to Sone's piece was obvious: the Buttermilk halfpipe is the site of the X Games' most daring stunts. It's where skiers and snowboarders launch themselves dozens of feet above the snow's surface, spinning and contorting like superhero gymnasts. They're gambling with their own bodies, rolling the dice on their physical futures.

Unlike the intentional use of aggression in Jennifer West's project, a kind of playful mayhem entered Sone's *Mt. 66* unexpectedly. After the dice bounced, rolled, and then skidded to a stop, children slid down the sides of the halfpipe and began pushing the giant cubes down the slope. It was an impromptu act of helpfulness. But just as the innocence of it all began to register, the kids, some appearing as young as six or seven, began tearing the dice apart. The acts were initially shocking, but against the setting of the halfpipe and the exuberant youth culture for which it serves as a backdrop, their participation quickly seemed perfectly in context. And when the children started sliding downhill on the slabs of plastic — taken from the dice and recycled as sleds — a sense of innocence returned. The whole enterprise ran through elements of

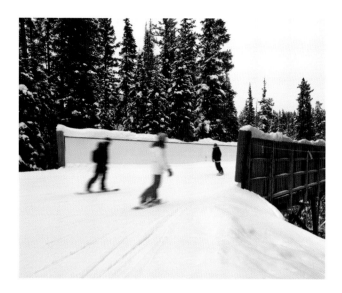

chance no one had foreseen: that the youngest generation of skiers and snowboarders would take immediate ownership of the artistic disruption's arrival on their turf.

The children at *Mt. 66* chose to engage with the disruption of their ski day. Not everyone makes the same decision. During the 2010–11 ski season, hundreds of skiers and snowboarders passed Susan Philipsz's audio installation at Snowmass and didn't give it a second thought. Some may not have heard Philipsz singing "White Winter Hymnal." Others, snowboarders in particular, were perhaps disinclined to lose their momentum on the relatively flat terrain. But for those who did stop, the song had the potential to change the ski day. It disrupted that most practical of moments on the slope: a traverse between runs. It took the expected and mundane and made it something else. What, exactly, that something was depended on the listener. For some, it simply served as a reminder to pause, much in the same way the diamond glinting of the snow might. For others, it merely proved a trifling curiosity.

Or, for those who listened to the song's beginning—"I was following the pack, all swallowed in their coats, with scarves of red tied round their throats"—Philipsz's voice might have hinted that the ski day could hold something more. Skiers and snowboarders willing to embrace the disruption might have seen an afternoon sliding downhill transcend to an experience with narrative potential, the white of the slopes converting to a canvas for the rest of the day.

That moment of contemplation, realized as snow-sliders blurred by like white noise, could have been a solitary or a shared one. And it could well have been both—a lone skier transfixed on Philipsz's voice might have looked up to discover a snowboarder sharing it with him. That, too, is typical of a day spent on the slopes. A ski mountain offers an ever-changing mix of experiences both singular and collective, oftentimes within the same run. A skier linking turns always does so individually, his focus entirely in the moment. But as soon as he rejoins his fellow snow-sliders, which may happen multiple

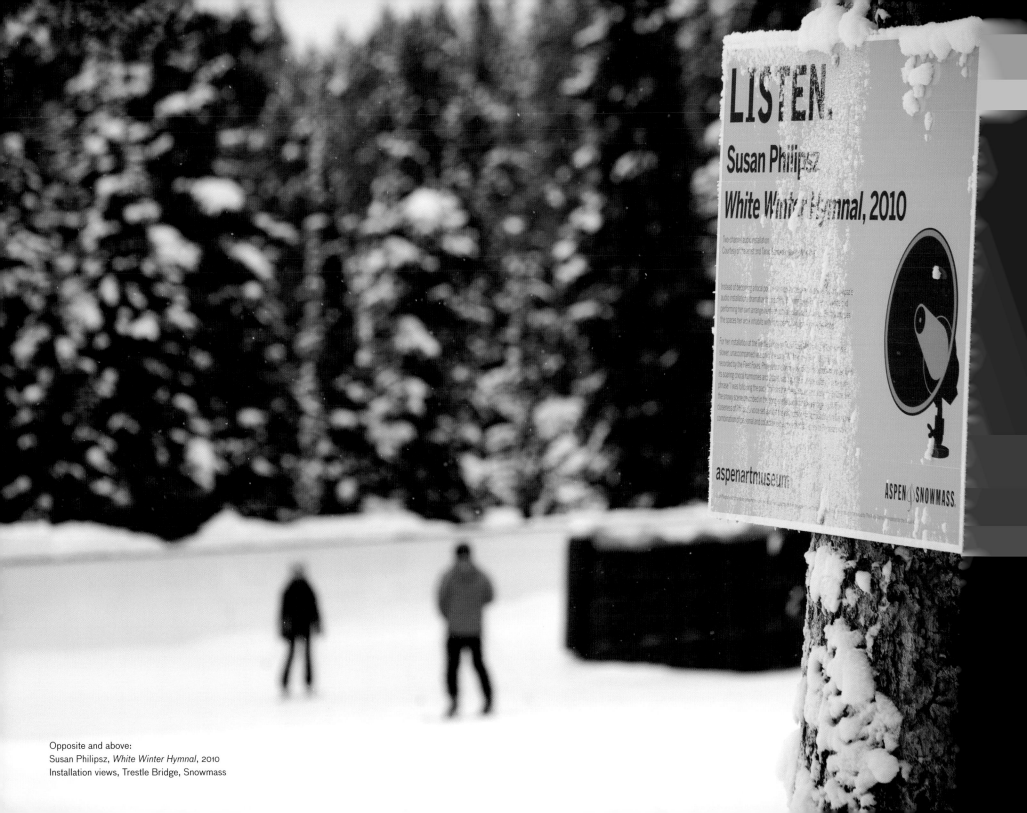

Opposite and above:
Susan Philipsz, *White Winter Hymnal*, 2010
Installation views, Trestle Bridge, Snowmass

times during a top-to-bottom descent, the experience becomes a collective one. It's a waxing and waning of group and individual interaction that occurs repeatedly over the course of any given ski day.

It was a dynamic captured in its extremes in the photographs of Walter Niedermayr's *Aspen Series,* exhibited at various Aspen Skiing Company locations from November 2010 through April 2012. In some of the works, whole slabs of mountainside were presented as vacant, allowing viewers to project themselves into a ski day passed in solitude. For his peopled images, Niedermayr layered multiple frames to present a slope exaggeratedly shared. Yet despite the sight of a few more skiers on Fanny Hill at Snowmass or Aspen Mountain's Little Nell run, there seemed an almost synchronized order to Niedermayr's teeming mountainsides. The skiers and snowboarders in his creations appear poised to come to life harmoniously, each frozen in the middle of the right turn at the right moment. The hoards of skiers don't encumber Niedermayr's slopes, they make them somehow more beautiful.

As with the work of Peter Doig, Niedermayr's photographs play off the most affecting skier emotion — memories of ski days past. Of course, everyone's memories are distinctive. They could be of a run experienced perfectly alone, of a riotous powder day shared with friends, or of days spent skiing moguls with younger knees. Or, perhaps best of all, they could be memories not of the past, but the implied, imagined ones of ski days yet to come.

If that sounds a touch saccharine, forgive it. A love for making turns can leave one prone to such exaggerated sentiment. As the locals say, even a single run can change the outlook of the day. And it's true.

That art could intrude on such a beloved, established experience and manage to leave an imprint is quite an accomplishment, though not solely for the artists who created the work. Ultimately, there would be no disruption, no unexpected intersection of culture, snow-slider, and nature, if not for the presence of all three things. The arrival of art on the scene simply offers Aspenites another way to frame and consider experiences and memories already held dear. It serves as a reminder: of where we are and why we're here.

Walter Niedermayr, *Aspen Series 32/2009*, 2009

UPLIFTING ART

Terry R. Myers

The exceptional collaboration between the Aspen Art Museum and Aspen Skiing Company that began in 2005 demonstrates that the connections between their respective enterprises are provocative and sustaining for both art and skiing, as well as for artists and their audiences wherever they can be cultivated, all the better when it involves a place with a real sense of community. It helps, of course, that the actual projects have involved a strong roster of internationally acclaimed artists. As an art critic who doesn't ski or snowboard the knowledge I lack about either is inversely proportional (I hope) to what I have about art, so I suppose that my circumstances are the reverse of what's anticipated by these collaborations—I would be drawn to the slopes *because* of this art rather than the other way around. With that said, I am struck that I have been directly engaged with the work of several of the artists who have contributed to this partnership, in some cases for more than twenty years. I also know some of them are almost as dedicated to skiing as they are to their art, so to be given an opportunity to combine the two must have been nothing less than ideal, and I am wholly supportive of providing artists with ideal opportunities, especially when the art (and its reception) is enhanced by them.

Provoked by my introduction to Peter Doig's work in the mid-1990s, I started thinking about connections between painting and snowboarding, usually when speaking with art students. As an attempt to challenge received notions that painting was "dead," my point at the time was that, while it was true that painting was no longer in the mainstream, it didn't mean that it was over. Rather, like snowboarding, it could be seen as a vibrant subculture reemerging at a

time in history in which the lines between mainstream and subculture were becoming increasingly blurred. Painting and snowboarding each had their own procedures (including, of course, "tricks" to expand their parameters), vocabularies, amateurs and professionals, magazines, parties, etc., and any or all of these things could provide a way in for the uninitiated, whether prospective painter or snowboarder, or, just as importantly, a new viewer and/or spectator. (There is, of course, also something to be said about viewers and spectators as *participants* in relation to this collaboration, as will be returned to below.) Therefore, Heidi Zuckerman Jacobson's vision of the lift tickets that adorn every skier and snowboarder's jackets as "blank canvases" strikes me as a quite insightful observation, one that brings art out of the museum and into the world in an unassuming yet effective manner. Moreover, the artwork-as-lift-ticket transforms each skier and snowboarder, turning each of them into his or her own "museum," albeit one that could be flying down a mountain at break-neck speed, but also one that has become, over the past six years, a necessary component of the growing relationship between great art and great skiing in Aspen.

Yutaka Sone, the first artist to contribute a design for a lift ticket (for the 2005–06 season), is an avid skier. Drawing from his experience in Aspen, Sone adapted his image from a painting that he made called *Ski Madonna* (2005) that depicts himself and museum staff member Christy Sauer Mahon navigating through a line of trees on Ajax Mountain's Trainor Ridge. By incorporating the ends of his skis at the bottom of the painting, Sone provides us

Yutaka Sone, *X-Games Site Model #1*, 2005

Yutaka Sone, *X-Games Site Model #2*, 2005

with the point of view of a participant, as we are asked to stand in his place while standing in front of his painting, a "pairing" that is made all the more suggestive when reproduced on a lift ticket for the actual slopes it depicts. Sone's painting was shown at the museum in 2006 in his exhibition *X-Art Show*, a title that refers to the annual Winter X Games hosted by the Aspen Skiing Company at Buttermilk Mountain. "X," of course, also refers to "extreme," a word that could be applied to Sone's accompanying work in sculpture, in which materials as diverse as papier-mâché, Styrofoam, crystal, and marble are used to produce oversized snowflakes, the occasional snowman, and even a mountaintop or two, challenging all along such distinctions as big and small, soft and hard, heavy and light. (He has said that he is more interested in snow when it is in the air rather than on the ground.) Sone played with all of

these classifications in his performative work on Buttermilk Mountain that involved two eight-foot multicolored dice. Transported by truck to the mountain, they were tossed by snowcat down the same superpipe used for the X-Games, pushed further down the mountain by spectators, and then returned by truck to the museum. Overall, Sone's comingling of painterly touch with material presence stands as a potent introduction into the uniqueness of this collaborative situation that so completely mirrors the visual and physical complexities of the site itself.

With that in mind, Peter Doig's 2006–07 contribution extends the implications of this mirroring. Returning to an image from what I have called his "skiing paintings" — in this particular case his *Study for Olin Mark IV* (1996) — Doig's image is among his most direct representations, locating the act of skiing in the moment, as an activity done with one's friends to have a good time. (Some of his other paintings from this time period show almost a party-type atmosphere, complete with show-off, "hot-dog" type moves.) As I wrote in 1998: "[the 'skiing' paintings] speak the language of the subculture represented in them (Doig is — or has been — a 'member'), and almost blankly provide his work with its most surface-level 'contemporary' moments The most significant connection to be made here is that the social ramifications of a 'practice' like skiing extend not only to the value of the making of the paintings for Doig, but also to their deliberate accessibility in subject matter and in material."[1] Doig's commitment to accessibility is supported by his other contribution to the collaboration, in his case a screening of several rarely seen "extreme" skiing films, an extension of his ongoing "Studio Film Club" program that he runs out of his studio in Trinidad, a project that has not only brought film culture to a new audience but also helped to build a sense of community.

The 2007–08 artist, Karen Kilimnik, took the collaboration to very different territory, that of absolute fantasy. Of course, this is where her work has been

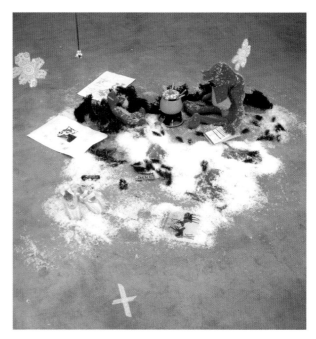

Karen Kilimnik, *Switzerland, the Pink Panther & Peter Sellars & Boris & Natasha & Gelsey Kirkland in Siberia*, 1991

from the very beginning. In 1991, I reviewed her very first solo show at 303 Gallery in New York, an exhibition that immediately identified her as one of the leading producers of installations that provoked the term "scatter art," as well as a pioneer in the reemergence of fictional yet personal subjectivity in contradistinction to the more political, identity-based art being made at the same time. I distinctly remember one of my favorite pieces, *Switzerland, the Pink Panther & Peter Sellars & Boris & Natasha & Gelsey Kirkland in Siberia* (1991), a mixed-media installation that included two stuffed Pink Panthers, artificial snow, ballet slippers, and a small fondue pot. Kilimnik has stayed true to many

of her favorite characters over the years, so it's not surprising that her painting, *Gelsey Stuck on the Matterhorn* (2000), shows the American ballerina referred to in the earlier work depicted this time and stuck incongruously on the famous mountain in Switzerland, complete with a bouquet of flowers (see p. 84). Overly romantic and seemingly self-confident about it, Kilimnik's image was a welcome reminder of the dreamy possibilities of the snow-covered peak, a fantastic place that many of us know more from the movies and other forms of popular culture than from first-hand experience.

In a text about his 2008–09 lift ticket project, Jim Hodges beautifully articulated his hopes for his collaboration and at the same time encapsulated the uniqueness of the opportunity: "For me, the problem is/was: What do I bring to this experience through my work that can touch each of these viewers? How deep can I go? I've skied those slopes, and I've contemplated the vastness of it all, the smallness of me, and the incredible privilege and luxury I live in! A great sense of gratitude always framed these reflective moments while riding up the chair to the next exhilarating run! These reflections gave me pause and it is in that 'space' created in such moments that I wanted to 'install' my work."[2] Mindful of the work of his artist peer and friend, the late Felix Gonzalez-Torres, Hodges's statement reminded me of a claim that I made in 1999: "Obviously Hodges's works 'place' us where there is something to be looked at, talked about, and remembered."[3] Hodges's lift ticket inspires all of these things and much more: proclaiming "GIVE MORE THAN YOU TAKE" in brightly colored cut-out letters, Hodges's contribution is, of course, the first in the series of lift tickets to use text, but more importantly it is the first to address an audience directly. Transformed into a mantra by its repetition on numerous lift tickets (as well as on three panels that were attached to the exterior of the museum during his accompanying exhibition), Hodges's work remained deliberately, even stubbornly, open-ended while driving its message home.

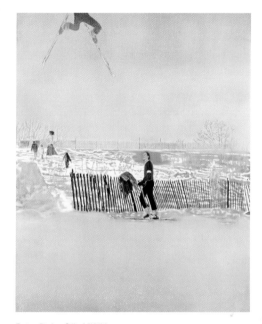

Peter Doig, *Olin MK IV*, 1995

Carla Klein's contribution to the 2009–10 season, *Untitled* (2009), returned the lift-ticket project to the landscape. Unlike, however, the paintings of Sone, Doig, and Kilimnik, Klein's is far more abstract and photographic: her paintings typically are based upon photographs that she takes, images that for her highlight the intervening effects of the camera as a technical instrument. In this context, her approach brings to mind the impact that mediation has upon skiing, or, for that matter, any activity that involves high-speed action, even if, in the end, her pictures show no direct evidence of any human presence, as is the case with *Untitled*. Instead Klein alludes to such a presence by taking the

27

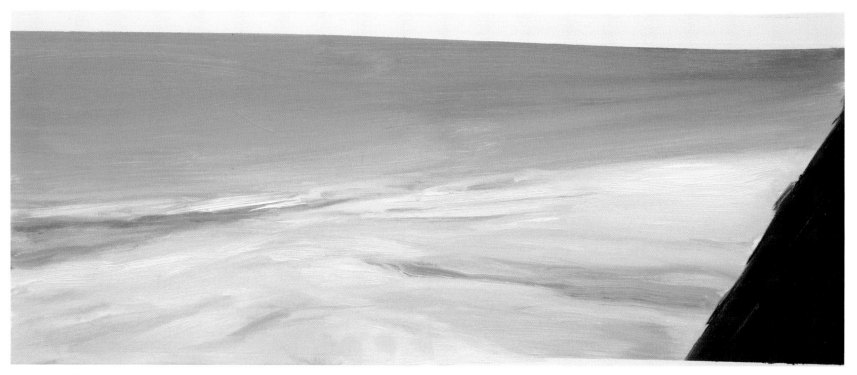

Carla Klein, *Untitled*, 2009

borders of a photographic image into account, as well as the format of the
lift ticket itself: "The photographs the final painting is based on were taken
from a helicopter hovering over a snowy Swedish landscape. It strikes me as
perfectly suited for a lift ticket, almost like a television screen with room at
the bottom for a subtitle. The standard size of photographic paper imposes the
white stripes one sees in my painted compositions and the dimensions of
the ski ticket act in much the same way — helping complete my compositional
process and making the image complete."[4] Klein's particular approach sug-
gests that she understands very well how we all "take" pictures with a camera
or, better yet, our eyes.

One of the lift tickets for the 2010–11 season reproduces a painting by Mamma Andersson titled *Sleeping Standing Up* (2003). Known for her dreamlike canvases in which incongruous juxtapositions of interior/exterior or public/private are seamlessly interwoven, Andersson also often incorporates direct representations of paintings by other artists (including Doig) into her work. And while such quotations are not readily apparent in *Sleeping Standing Up*, there is a tangible sense of displacement between the nearly ethereal landscape and the far more physical forms that are partially visible inside the windows of a large yet still domestic building that somehow is barely there. Extending painting's longstanding and critical engagement with both absence and presence, Andersson's contribution to the lift-ticket series also reinforces Zuckerman Jacobson's recognition of the potential of such small-scale "blank canvases" as meaningful sites for the ways in which landscape continues to inspire artists, if not painters in particular. I'm reminded here of how often artists maintain a type of "inspiration wall" in their studios for postcards of other works of art. Even with the Internet and the rise of the JPEG, they've hardly disappeared. Moreover, in my opinion, one of the more unique aspects of this partnership between the Aspen Art Museum and Aspen Skiing Company is that it has included so many significant painters, including, I would argue, the other 2010–11 participant who happens to be a photographer.

Walter Niedermayr's season pass, based on an image of the Highland Bowl that was commissioned by Aspen Skiing Company as a part of a major body of work titled *The Aspen Series*, technically is the only one that is a reproduction of a photograph. However, Niedermayr's works are not your average photographs: large-scale, multipaneled, and sometimes presented backlit by light boxes, his works, along with those of artists like Andreas Gursky, Thomas Struth, and Jeff Wall, give credence to a way of thinking about painting that emerged at the beginning of the twenty-first century: that painting could now be understood as a philosophical category rather than a material one.[5]

2010–11 lift ticket featuring Mamma Andersson, *Sleeping Standing Up*, 2003

Niedermayr himself has stated, "Through multiplicity, an instantaneous photographic image breaks the concept of place and time. This literally amplifies the 'horizons' of our perception."[6] Challenging the boundaries between painting and photography alongside Doig, Klein, and Andersson, yet from the "other" direction, Niedermayr's work helps to complete a perfect conceptual circle within the parameters of all of the projects to date, a circle that extends its reach beyond the specifics of Aspen and, I would argue, connects to the larger history of the relationships between art and leisure activity, if not between nature and culture itself, a point made crystal clear in the placement of his large images in the vast landscape from which they were made.

Despite my own long-term dedication to painting, it is particularly encouraging that the collaboration between the museum and Aspen Skiing Company has extended its territory since 2010, moving into much more involved collaborations between artists and the community, and also exploring new ways of producing and/or situating art works on the slopes themselves. In the first category,

Walter Niedermayr, *Aspen Series 34/2009*, 2009

Jennifer West's project for the Bud Light Spring Jam 2010, a film called *Shred the Gnar Full Moon Film Noir* (2010), involved skiers and snowboarders in the artistic production of the work itself, a process that not only involves direct physical interaction with the film stock that she uses — in this instance a film of images of the moon that was shot by Peter West was repeatedly rode over by her extremely active collaborators — but also makes use of various substances that are connected to the social situation of its making: involving in this case an Epsom salt bath in a hot tub, and rubbings with arnica gel, Tiger Balm, K-Y jelly, butter, and Advil. West's project makes clear that part of what makes these collaborations work so well is that they can be fun, rather than being yet another example of art being forced into a situation where no one can have a good time.

Finally, Susan Philipsz's *White Winter Hymnal* (2010) is a promising example of the possibilities for placing an artwork into an unexpected situation where it very much does belong. Installed at the Trestle Bridge on Snowmass Mountain, Philipsz's sound piece works in tandem with its surroundings. Using her own voice, Philipsz's recording of her slowed rendition of the song "White Winter Hymnal," originally recorded by the Fleet Foxes, creates a surprising intimacy within the immensity of its surroundings, while also making direct reference to its passing audience in the lyrics: "I was following the pack." Given the extent to which art has become more and more about an interaction between the work and its site, and, by extension, its audience, it is clear that with this latest endeavor the Aspen Art Museum and Aspen Skiing Company are way ahead of the game when it comes to uplifting art and its audience,

cultivating a unique situation for both artist and audience, not to mention the art works themselves. (And for me at least it always has to be all about the art!) By starting with the simple yet provocative gesture of taking art directly to its potential viewers — literally attaching it to their clothing — and then allowing for each collaboration to expand and transform to suit a wide range of conditions, this project proves itself in the end to be a fantastic model for how to create the type of ideal situation that I know artists are always looking for while also enabling both artist and audience to come together as active, willing participants.

Notes

1. See my "Jumping the gun, better than dead: what's next in Peter Doig's paintings," in *Peter Doig: blizzard seventy-seven* (Kiel, Nürnberg and London: Kunsthalle Kiel, Kunsthalle Nürnberg and Whitechapel Art Gallery, 1988), 65–72.

2. Jim Hodges, "2008/09 Lift Ticket Project," accessed July 27, 2011, at http://www.aspenartmuseum.org/archive_hodges_lift_ticket.html

3. See my "He's not Here: Terry Myers visits Jim Hodges' studio in New York," *TRANS>arts.cultures.media*, vol. 6 (1999): 174.

4. Carla Klein, quoted in Aspen Art Museum, "The Aspen Art Museum and the Aspen Skiing Company: Six Years of Collaboration," news release, November 2010.

5. Howard Halle makes this point in a review of an exhibition of the work of Andreas Gursky in his "Photo-unrealism," *Time Out New York*, December 30, 1999–January 6, 2000, 55–6.

6. Walter Niedermayr, quoted in "Walter Niedermayr: *The Aspen Series*," exhibition guide (Aspen, CO: Aspen Skiing Company, 2010).

TIMELINE

Aspen Art Museum/Aspen Skiing Company Collaborations
Exhibitions, artists' projects, public programs, and educational programs

2005-06

NOVEMBER	DECEMBER	JANUARY	FEBRUARY	MARCH	APRIL

YUTAKA SONE

Mt. 66: dice toss and
music performance
February 19, 2006
Buttermilk

**LIVE GRAFFITI AT
THE 2006 BUD LIGHT
SPRING JAM**

March 2006 | Aspen

YUTAKA SONE

2005–06 Lift Ticket:
Ski Madonna (2005)

Exhibition: *X-Art Show,*
February 17–April 16, 2006 |
Aspen Art Museum

2006-07

NOVEMBER	DECEMBER	JANUARY	FEBRUARY	MARCH	APRIL

**CREATE YOUR OWN LIFT
TICKET @ BUTTERMILK**

Inspired by artist Peter Doig
February 18, 2007

**Historic
Ski Movies**

**APRÈS-SKI FILMS
WITH PETER DOIG**

Sky Hotel, 39° Bar
February 16, 2007
Aspen

**ASSUME VIVID ASTRO FOCUS
AT THE 2007 BUD LIGHT SPRING JAM**

March 2007 | Aspen

MAY | JUNE | JULY | AUGUST | OCTOBER

2 Day AD
Window AD
$164.00

PETER DOIG

AGES 18-64

11/23/2006

SNOWMASS • ASPEN MOUNTAIN
ASPEN HIGHLANDS • BUTTERMILK
ASPEN SNOWMASS.
2006-2007 SEASON
YOU'RE RESPONSIBLE — SKI/RIDE WITH CARE

PETER DOIG

2006–07 Lift Ticket:
Study for Olin Mark IV (1996)

2007-08

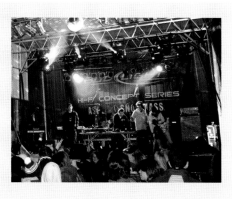

**PSYCHEDELIC FILMS
AT THE 2008 BUD LIGHT
SPRING JAM**

March 2008 | Aspen

KAREN KILIMNIK

2007–08 Lift Ticket: *Gelsey Stuck on the Matterhorn* (2000)
Exhibition: December 14, 2007–
February 3, 2008
Aspen Art Museum

CREATE YOUR OWN LIFT TICKET @ BUTTERMILK

With artist Karen Kilimnik
December 15, 2008

2008-09

CREATE YOUR OWN LIFT TICKET @ SNOWMASS

With artist Jim Hodges
February 14, 2009 | Treehouse
Kids' Adventure Center

PATTERSON BECKWITH AT THE 2009 BUD LIGHT SPRING JAM

March 20, 2009
Aspen and Snowmass

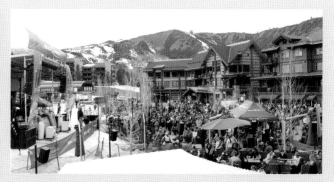

GIVE MORE THAN YOU TAKE

SNOWMASS · ASPEN MOUNTAIN
ASPEN HIGHLANDS · BUTTERMILK

ASPEN SNOWMASS.

2008 – 2009 SEASON
YOU'RE RESPONSIBLE – SKI/RIDE WITH CARE

JIM HODGES

2008–09 Lift Ticket: *Give More Than You Take* (2008)

Exhibition: *you will see these things*, February 13–May 3, 2009
Aspen Art Museum

2009-10

**CARLA KLEIN IN
DISCUSSION WITH HEIDI
ZUCKERMAN JACOBSON**

March 11, 2010 | Aspen Art Museum

**CREATE YOUR OWN LIFT
TICKET @ SNOWMASS**
With artist Carla Klein
March 13, 2010 | Treehouse Kids'
Adventure Center

MAY | JUNE | JULY | AUGUST

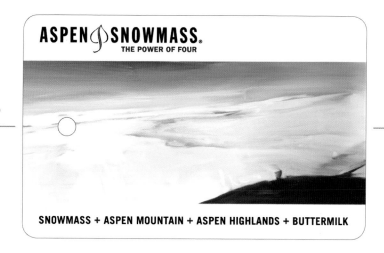

ASPEN SNOWMASS.
THE POWER OF FOUR

SNOWMASS + ASPEN MOUNTAIN + ASPEN HIGHLANDS + BUTTERMILK

CARLA KLEIN

2009–10 Lift Ticket:
Untitled (2009)

JENNIFER WEST

Shred the Gnar Full Moon Film Noir film production
Kick Aspen Big Air competition, March 19, 2010
Aspen Mountain
Fallen Friends Memorial, March 20, 2010 | Aspen Highlands

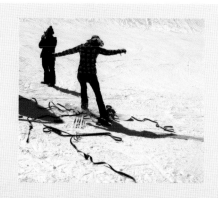

JENNIFER WEST AT THE 2010 BUD LIGHT SPRING JAM

Shred the Gnar Full Moon Film Noir (2010)
film screening March 26–28, 2010 | Aspen

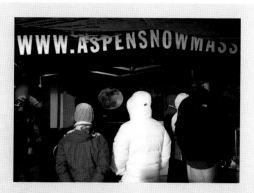

WALTER NIEDERMAYR

2010–11 Season Pass: *The Aspen Series*
72/2009 and 77/2009 (2009)

Exhibition: *The Aspen Series,* November 2010–
April 2012 | Aspen Skiing Company locations
in Aspen and Snowmass

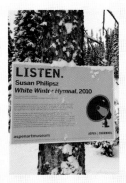

SUSAN PHILIPSZ
Sound installation: *White
Winter Hymnal* (2010)
December 10, 2010–
February 21, 2011
Snowmass Mountain

CREATE YOUR OWN LIFT TICKET
Inspired by Mamma Andersson
December 11, 2010, Treehouse
Kids' Adventure Center
Snowmass
March 12, 2011 | Buttermilk

DAVID BENJAMIN SHERRY AT THE 2011 BUD LIGHT SPRING JAM
March 18, 2011 | Aspen

MAMMA ANDERSSON

2010–11 Lift Ticket:
Sleeping Standing Up (2003)
Exhibition: December 10, 2010–
February 6, 2011 | Aspen
Art Museum

RESTLESS EMPATHY

Exhibition, May 21–July 18, 2010
Aspen Art Museum and Aspen

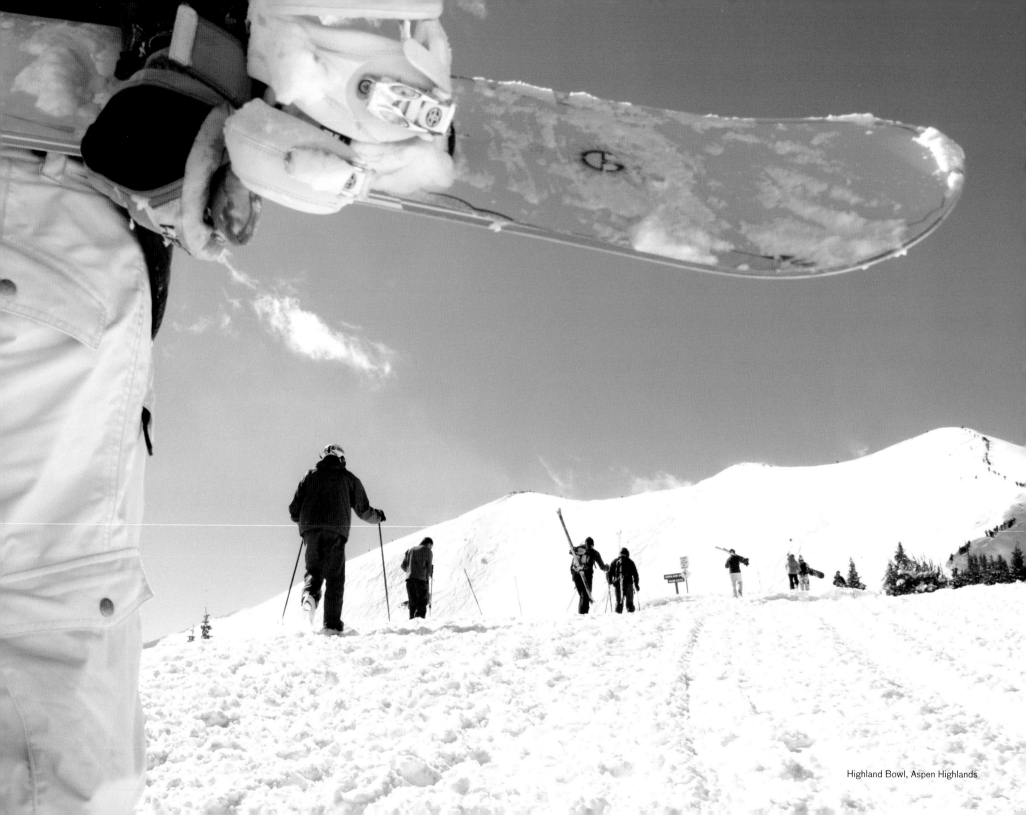

Highland Bowl, Aspen Highlands

THE ARTISTS

Interviews, Original Writing, Project Commentary

Yutaka Sone

2005–06 Lift Ticket: *Ski Madonna* (2005)
Exhibition: *X-Art Show,* February 17–April 16, 2006 | Aspen Art Museum

The following is an excerpt from a February 15, 2006, interview by Heidi Zuckerman Jacobson.

HEIDI Yutaka Sone was raised skiing and mountain climbing in Japan. He has a master's degree in architecture, and he has lived in Los Angeles for the past six years where he has a home and a studio. Yutaka, tell us a little bit about your *X-Art Show* exhibition. How did you come up with the title?

YUTAKA The title comes from the name of the skis. Maybe Rossignol Bandit X, Bandit XX, Bandit XXX. Or X Games.

H One of the things that I know about you is that you love snow. You just had an opening in Chicago at the Renaissance Society, and two of the things that I liked about that show relate to what we're talking about. One is that you made all of these beautiful drawings of snowflakes, and instead of having them on the walls, you had them installed on the ceiling and at all these different kind of angles. Then you also had these snowflakes, which were, as I understand it, drawings of snowflakes where you crumpled up the paper and placed the round pieces of paper on a pedestal. In the show at the Aspen Art Museum, you have two maquettes, and we talked about the fact that though they are traditional sculptures, we could also position them like snowballs.

Y That installation was totally different. I focused more on the sculpture and installation serving the museum at Chicago. This time my project is to get into the whole environment in Aspen, including the museum.

H Can you talk about the performance at the halfpipe at Buttermilk?

Y They're dice. So if I cannot get a good number, I think I will do it again.

H So we might see the dice roll twice on Sunday?

Y I am very excited to see them roll.

H The Aspen Art Museum worked with you on fabricating these dice, and they're all covered in P-Tex, which is the material that is on the bottom part of skis. What are you going to do to make those dice go fast, wax them up?

Y Yeah. We're selecting a wax now, and we're going to adjust, kind of find the perfect temperature for Buttermilk on Sunday, I hope. After waxing the dice, I think the dice will get a good speed.

H There have been a lot of people from the Aspen Skiing Company who have been very helpful to us in this project, right?

Y They are great. They really care about the whole crazy performance.

H The original painting of the image on the ski ticket is called *Ski Madonna* (2005) , and it was painted nearly a year ago. Your partner here in skiing, Christie, works for us at the Aspen Art Museum. Why did you chose that title?

Y Oh, because she is the Ski Madonna in Aspen.

H You and I skied together on Saturday at Buttermilk, and we started off our day in the ticket office. You saw in there a very large poster of the lift-ticket image, letting people know about the collaboration and that they can come to the museum to see the exhibition. Then, as we were going around the mountain, you could see the ski tickets hanging off everyone's jackets.

Y I was so happy. I was thinking how art can communicate in the real world, and how some art should survive. Not survive — more like "have to work in society." I was thinking a long time about those things. When I see the tickets and that many kids and skiers had the ticket, which has my painting, I was so happy, very happy. I felt it a wonderful achievement of our art.

SNOWMASS • ASPEN MOUNTAIN
ASPEN HIGHLANDS • BUTTERMILK
ASPEN ⚡ SNOWMASS®
2005-2006 SEASON
YOU'RE RESPONSIBLE — SKI/RIDE WITH CARE

2005–06 lift ticket
Opposite: Yutaka Sone, *Ski Madonna (#1)*, 2005

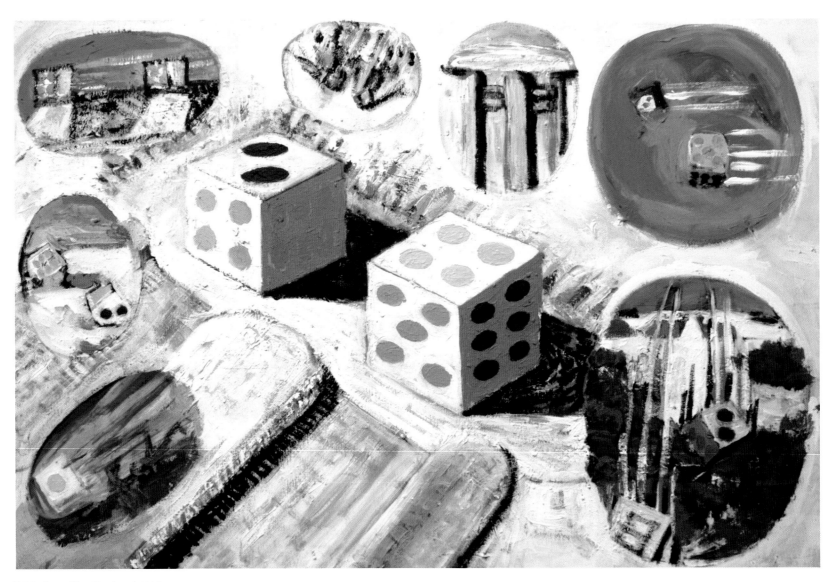

Yutaka Sone, *Dice, Storyboard*, 2005

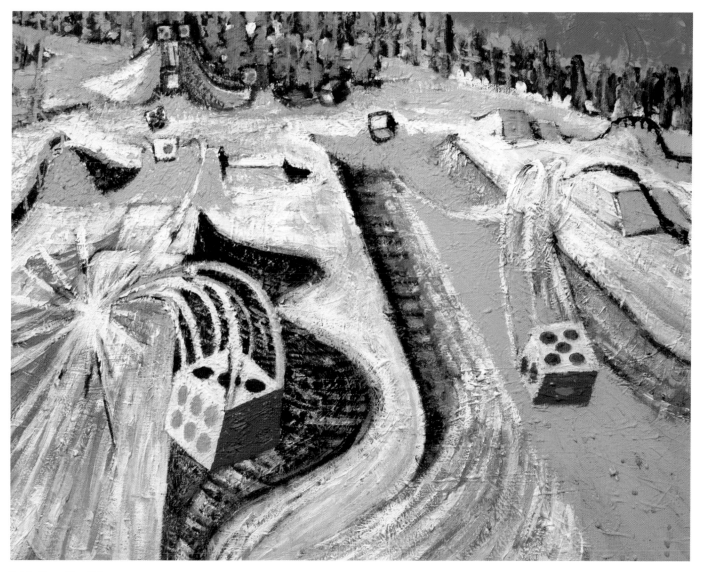

Yutaka Sone, *Dice, X-Games*, 2005

H I think that's a really important point. One of the things that we talk about all the time at the museum and as a personal mission for myself is how to bring more art to the people. This is the most incredible way to engage audiences here because people come to Aspen primarily to ski. Now, they're all skiing with your *Ski Madonna*. They all have a work of art hanging from their jackets. I think a lot of people will notice that it looks a little different than the ticket they got at Vail, at Lake Tahoe, or in Burlington, Vermont, and they'll have that moment where they pause and say, "What is this?" Then they turn the ticket over to see "Ticket Image Artist, Yutaka Sone, Courtesy of Aspen Art Museum."

Y Wow. I kind of like this kind of challenge. So if I have a chance to do another show in Aspen, just call me again, please. I will come and make another project.

H I like that your paintings are very active, and that what's happening in them is not something from a photograph. You don't ever paint from photographs. You paint from your memory and from other people's memories, which is really different than a lot of the ways people are making paintings now.

Y My style has adjusted. When I have a very impressionable moment, I want to start painting, and that's the style. I paint what I remember.

H There's one painting in the exhibition that we don't have an image of here today, but it's from when you were camping at the bottom of Mount Everest. When you were talking with me about the painting, you said the top of the painting is finished because you can remember the peaks of the mountains, and the bottom is finished because you can remember what it was like where you stayed. But in the middle it's not quite finished because your memory sort of faded. But you plan to finish that painting, maybe.

Y Yeah.

H That reminds me of another painting that's in the show, which is of the gondola on Aspen Mountain. On the back of that painting, which, of course, people won't see because it's hung on the wall, is an e-mail from Matthew Thompson, the Assistant Curator at the Museum, describing exactly what the gondola looks like. You read the e-mail and made the painting.

Y That's my style.

H It's a great style, a very unique style. Who you are as a person and your perspective on the world are very integrated into your art work. They are one and the same, and throughout history people have talked about life imitating art and art imitating life. When there's a successful fusion, I think that's the most successful art. I would say your work is very much about who you are and your energy and your feelings and your impressions. That's something I very much appreciate about what you do, and I'm so excited that you brought it here to us at Aspen and at the Aspen Art Museum. In fact, it's not just at the museum — it's going to be on Buttermilk Mountain, and it's with everyone who comes to Aspen to ski. That's really a pretty incredible thing.

Y You're welcome.

Yutaka Sone was born in 1965 in Shizuoka, Japan, and lives and works in Los Angeles. Sone's dice projects, which have to do with chance, mysticism, and transcendence in daily life, have also been performed abroad in Australia and Germany, and in the US at ArtPace in Austin, Texas. His one-person exhibitions include Tokyo Opera City Art Gallery (2011); Maison Hermès Le Forum, Tokyo (2010); Parasol unit foundation for contemporary art, London (2007); Kunsthalle Bern, Switzerland; Aspen Art Museum, Colorado; and The Renaissance Society at the University of Chicago (all 2006); and The Museum of Contemporary Art (MOCA), Los Angeles (2003). Selected group exhibitions include *BadLands: New Horizons in Landscape*, Massachusetts Museum of Contemporary Art, North Adams (2008) and the 25th São Paulo Biennial (2003). Along with Motohiko Odani, Sone represented Japan at the 50th Venice Biennale (2003). His work is held in many museum collections, including the High Museum, Atlanta; Kunsthalle Bern, Switzerland; Art Institute of Chicago; MOCA, Los Angeles; The Museum of Modern Art, New York; and the Tate Gallery, London.

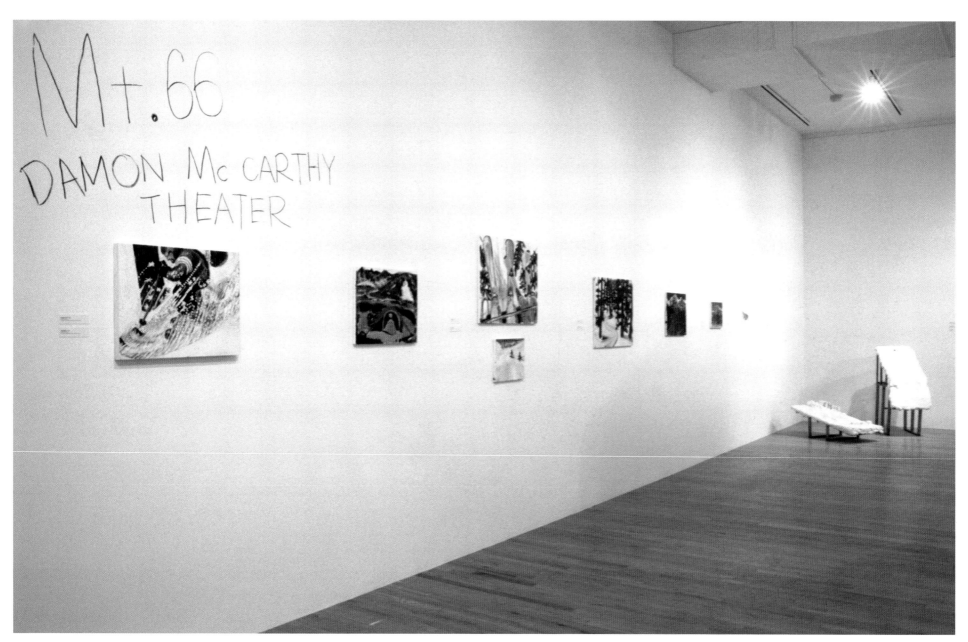

Yutaka Sone: *X-Art Show*. Installation views, Aspen Art Museum, 2006.

Peter Doig

2006–07 Lift Ticket: *Study for Olin Mark IV* (1996)

The following is a September 9, 2011, interview by Heidi Zuckerman Jacobson.

HEIDI How did you come to do the lift ticket here in Aspen and why did you want to do it? Why it was exciting and appealing to you?

PETER I suppose my own history of skiing and also having made quite a number of snow and ski paintings, if you like. And just the idea of this little pass that everyone who skis knows about but that has an image, an artist's image on it. It's just an exciting idea, really, something that I haven't seen before. These tickets usually have a logo, or something like that on them. That can be pretty good, of course, but they're usually somewhat inane or boring.

H You've spent a lot of your life skiing?

P I've spent a lot of my life skiing. I grew up in Quebec, in eastern Canada, and we lived in an area of hills, I would say, not mountains. It's like straight north of the Adirondacks. It snows six months, usually every year, so we'd ski a lot. And then I continued skiing as an adult. After I left, I skied in Europe and then various places in the States.

H What do you like about skiing?

P About skiing?

H Yes.

P The thing I like about it now, I suppose, it's a kind of escape in a way, an escape from everything. It's a way of seeing into the distance that you don't normally look at in everyday life. That traveling up the lift, I think it's just something you take for granted, but actually it's a time when you think and really relax. I like the challenge of it. I like so much about it. It's hard to say really.

H Do you think skiing is creative?

P I do think it is. I think there are lots of very creative skiers out there. I think there are skiers who you enjoy skiing with and watching a lot more than others. So I would say it's creative, yeah. How one chooses to descend is also very much up to the individual and is an expression of sorts.

H It is interesting, because as we have worked on this book, I have learned about the idea of skiing in a more expansive way, because until now I really only had my own perspective on it. It is not something I had thought that much about before. But people have now talked to me about skiing as something that is creative, expressive, romantic, or poetic. So it is interesting for me to hear some of these terms that I associate more with art, or other forms of creativity, being applied to skiing.

P Yeah. I suppose it's a very, I would say unique sporting activity. I'm not talking about competitive skiing; I'm talking about free skiing. I enjoy free skiing much more than competitive skiing. I've never really been interested in that other aspect of skiing other than watching racing and stuff like that.

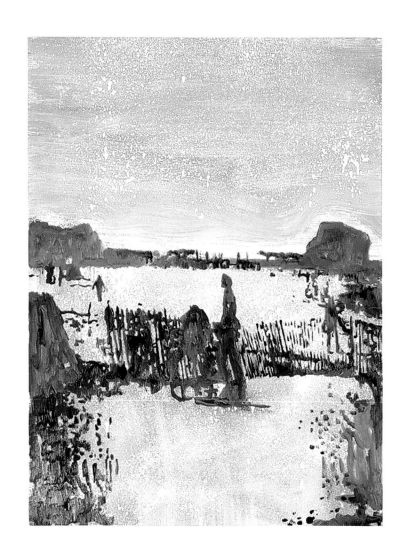

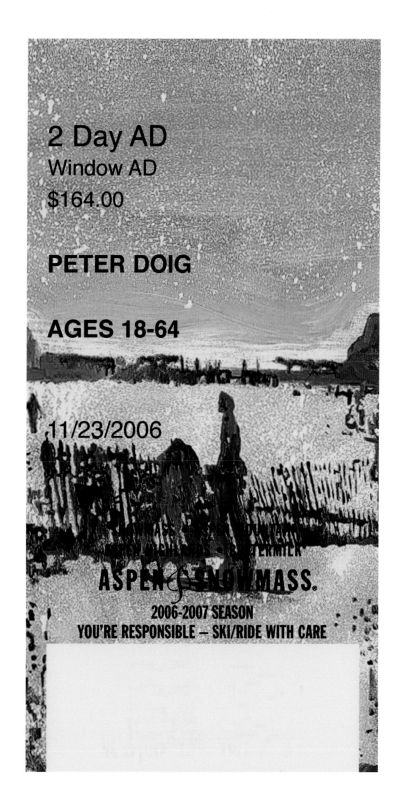

2 Day AD
Window AD
$164.00

PETER DOIG

AGES 18-64

11/23/2006

ASPEN SNOWMASS.
2006-2007 SEASON
YOU'RE RESPONSIBLE – SKI/RIDE WITH CARE

2006–07 lift ticket
Opposite: Peter Doig, *Study for Olin Mark IV*, 1996

P But I think it's a weird sort of self-expression, really. A lot of it happens in your own mind. You rarely see yourself skiing. In some ways you have no idea of what you look like or how good you are, whatever that means. It's something that is in your head, and your head sort of dictates your body and your choices. I think it's very creative in that respect.

H It's such an interesting idea, right, that this thing happens, and it's happening in reality. But you're talking about the fact that it's also happening in your own mind, and that's the imagistic part of it. I think that's fascinating.

P Yes, that's right. I think you also take your equipment for granted, really — how perfect the medium is, this kind of advanced technology that it is now, although it was still fun when it was much more primitive, where you just had lace-up boots and stuff like that. So there is a precision element that has been designed by scientists or whatever, but then there are natural elements, which are perfect. There's a kind of gravity, or lack of gravity, that helps you to descend in this incredible medium, which is the snow, and then all the varieties of that. It's a very, very special activity. I don't really think of it as a sport. It's hard to describe what it is. It's sort of like a pleasure more than a sport.

H Yes, or a practice even.

P A practice. I think you actually have to be fit to ski, but you also have this gravity. Anyone can descend. It's like running. Maybe you are descending, but that's when things come into play. Once you start moving, you have to then start using all of these different things you learned to become natural and to stop thinking about the running. You actually need the toe, you have to make a turn. That's what is so incredible about it.

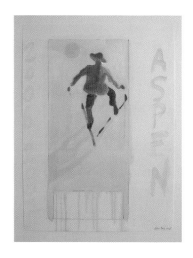

Peter Doig was born in Edinburgh, Scotland, in 1959, and now lives and works in Trinidad. He was awarded the Whitechapel Art Gallery's Artist award in 1991, and was short-listed for Britain's prestigious Turner Prize in 1994. His one-person exhibitions include Tate Britain, London (2008); *Go West Young Man*, Museum der bildenden Künste, Leipzig, Germany (2006); and *Peter Doig / MATRIX 183: Echo Lake*, The Berkeley Art Museum and Pacific Film Archive, California (2000). His work has been featured in the group exhibitions *Marlon Brando, Pocahontas, and Me*, Aspen Art Museum, Colorado (2008); *The Painting of Modern Life*, The Hayward Gallery, London (2007); *Eye on Europe*, The Museum of Modern Art, New York (2006); and *The Triumph of Painting*, The Saatchi Gallery, London (2005), among others. Doig's work is featured in many of the world's premier museum collections, including The Art Institute of Chicago; The British Museum, London; the Dallas Museum of Art; The Museum of Contemporary Art (MOCA), Los Angeles; the National Gallery of Canada, Ottawa; MoMA, New York; and the Tate Gallery, London.

Peter Doig, *Figure in
Mountain Landscape*, 1997–98
Opposite: Peter Doig, *Untitled*, 2006

Karen Kilimnik

2007–08 Lift Ticket: *Gelsey Stuck on the Matterhorn* (2000)
Exhibition: December 14, 2007–February 3, 2008 | Aspen Art Museum

The following is an August 18, 2011, interview by Heidi Zuckerman Jacobson.

HEIDI Why do your paintings take the style of historical genre painting, especially portraits and landscapes, so often?

KAREN Because I like these subjects very much.

H In addition to your mountain paintings, you've also made many of the ocean and the sky. What is it about the natural world that makes you return to it again and again as a subject?

K Because I love nature and the way humans take care of the earth is destroying it.

H Tell me about your experience in Aspen when you came here for the opening of your exhibition. What made the strongest impression when you first arrived?

K I loved the snow, the lunch at Hotel Jerome, the delicatessen that had the salmon burger, wild west lettering everywhere, and the mountains all around Aspen.

H What was your experience like taking the gondola up the mountain?

K I loved it. I loved going up the mountain and the view and the restaurant at the top.

H You also attended my daughter's ballet class during your trip. What do you like most about ballet?

K The music, the nice manners, and the gracefulness.

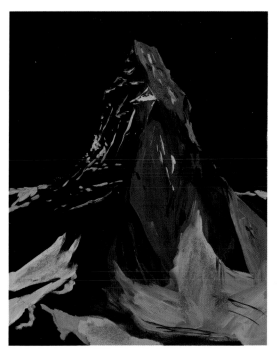

Karen Kilimnik, *The Matterhorn at night, dreamland, 9pm, 3am, Zermatt*, 2007

Karen Kilimnik was born in 1957 in Philadelphia, where she currently lives. She has had solo exhibitions at Il Capricorno, Venice, Italy, and 303 Gallery, New York (2011); the Musée d'Art Moderne de la Ville de Paris (2006); and the Historisches Museum, Basel, Switzerland (2005). Her first major survey was presented in 2007 at the Institute of Contemporary Art at the University of Pennsylvania, Philadelphia, and toured to the Museum of Contemporary Art, Chicago; Museum of Contemporary Art, Miami; Serpentine Gallery, London; and the Aspen Art Museum. Her work has been included in numerous group exhibitions: among them, *Picture Industry (goodbye to all that)*, Regen Projects & Regen Projects II, Los Angeles (2010); *Order, Desire, Light*, Irish Museum of Art, Dublin (2008); *Old School*, Hauser and Wirth Colnaghi, London; *Defamation of Character*, PS1, New York (2006); and *Drawing from the Modern 1975–2005*, The Museum of Modern Art, New York (2005).

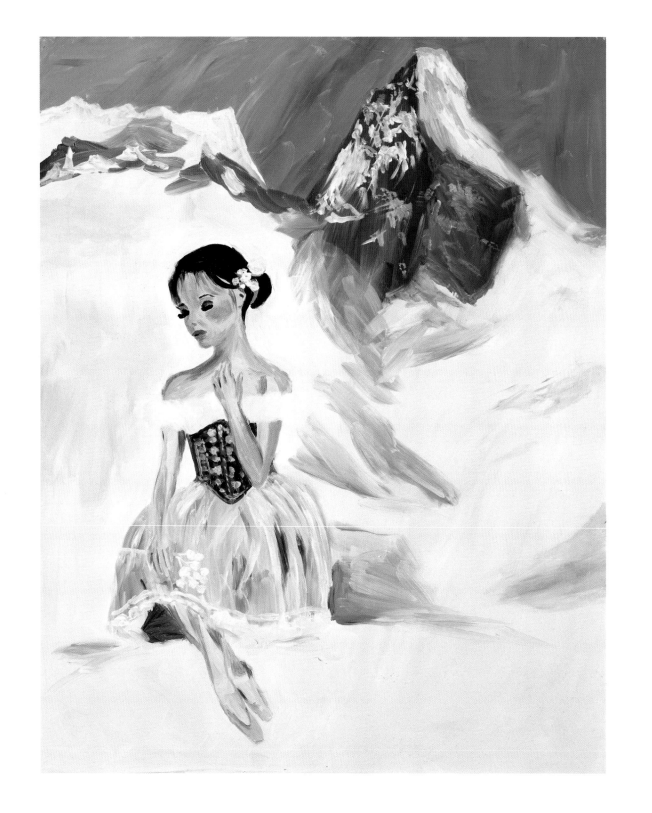

SNOWMASS • ASPEN MOUNTAIN
ASPEN HIGHLANDS • BUTTERMILK

ASPEN SNOWMASS.

2007 – 2008 SEASON
YOU'RE RESPONSIBLE – SKI/RIDE WITH CARE

2007–08 lift ticket
Opposite: Karen Kilimnik,
Gelsey Stuck on the Matterhorn, 2000

Karen Kilimnik (exhibition)
Installation views,
Aspen Art Museum, 2008

Jim Hodges

2008–09 Lift Ticket: *Give More Than You Take* (2008)

Exhibition: *you will see these things*, February 13–May 3, 2009 | Aspen Art Museum

Accepting an invitation to interact with a space, any space, engages me at the core. Each invitation and opportunity raises questions: "What's here? Where am I in relationship to this space? How do I honestly articulate a response to the specific needs, audience, and context of the space?" Each brings its limitations and edges, and invites me to reach deep inside myself to respond with an articulate sculpted form infused with the essence of what's driving me in that particular moment. Each opportunity also comes with the potential for realizing, at best, something new, or, at worst, reengaging with longstanding commitments of ideas and practices. The invitation to fill a space is an exciting privilege and one I never take for granted.

The lift-ticket opportunity challenged me to rise to a very unique occasion, one that extended the terrain of my practice into the wild blue, and one where the work would be experienced in the most casual way — almost invisible as a background for the lift-ticket text. Also, where the "viewer" could be anyone from a full spectrum of people of all ages and backgrounds out to enjoy the beauty and excitement of skiing through some of the most breathtaking terrain on the planet Not a bad context for sure!

For me, the problem is/was: What do I bring to this experience through my work that can touch each of these viewers? How deep can I go? I've skied those slopes, and I've contemplated the vastness of it all, the smallness of me, and the incredible privilege and luxury I live in! A great sense of gratitude always framed these reflective moments while riding up the chair to the next exhilarating run. These reflections gave me pause and it is in that "space" created in such moments that I wanted to "install" my work.

Having spent the summer researching sustainable energies and lifestyles and reading many books on related subjects — from works by radical environmentalists to Dee Brown's *Bury My Heart at Wounded Knee* (1970) — I was primed to ask a question in the form of a statement: *"give more than you take."*

The simplicity of that phrase, multifaceted like a crystal, can be applied to many of life's issues, ranging in subject from economic principles to simple manners of behavior. That range is as rich and varied as the people who enjoy the sublime context of the mountains. In relationship to the mountain and the context of skiing, I think the words have the potential to elicit a variety of responses. A spectrum of responses is a beautiful thing. Not everyone will read it, and many who do won't give it a thought.

Art is life. It isn't a single thing. There are no guarantees. It challenges and rewards. We get what we choose from it. It is an invitation to experience. I wanted to give the lift ticket something powerful and something beautiful. Beauty is the motivating energy that powers my life and the work I make. Beauty is ultimately what I wish my work to give — beauty of experience.

— Jim Hodges

Jim Hodges was born in Spokane, Washington, in 1957. His work is featured in the permanent collections of The Dallas Museum of Art; the San Francisco Museum of Modern Art; The Museum of Contemporary Art (MOCA), Los Angeles; The Museum of Modern Art (MoMA), New York; and the Guggenheim Museum, New York; as well as The Museé National Centre Pompidou, Paris, and the Tate in London. In 2009 he debuted his *you will see these things* exhibition at the Aspen Art Museum; other solo exhibitions in 2009 included the Centre Pompidou, Paris, an exhibition which also traveled to the Irish Museum of Modern Art, Dublin, and the Camden Arts Centre in London. His work has been featured in dozens of group exhibitions, including *Floating a Boulder: Works by Felix Gonzalez-Torres and Jim Hodges*, Flag Art Foundation, New York (2009); *Like color in pictures*, Aspen Art Museum, Colorado (2007); *I Remember Heaven: Jim Hodges and Andy Warhol*, Contemporary Art Museum, St. Louis (2007); and *SHINY*, Wexner Center for the Arts, Columbus, Ohio (2006).

GIVE MORE THAN YOU TAKE

GIVE MORE THAN YOU TAKE

SNOWMASS · ASPEN MOUNTAIN
ASPEN HIGHLANDS · BUTTERMILK

ASPEN SNOWMASS®

2008 – 2009 SEASON
YOU'RE RESPONSIBLE – SKI/RIDE WITH CARE

2008–09 lift ticket
Opposite: Jim Hodges,
Give More Than You Take, 2008

Jim Hodges: *you will see these things*. Installation views, Aspen Art Museum, 2009.

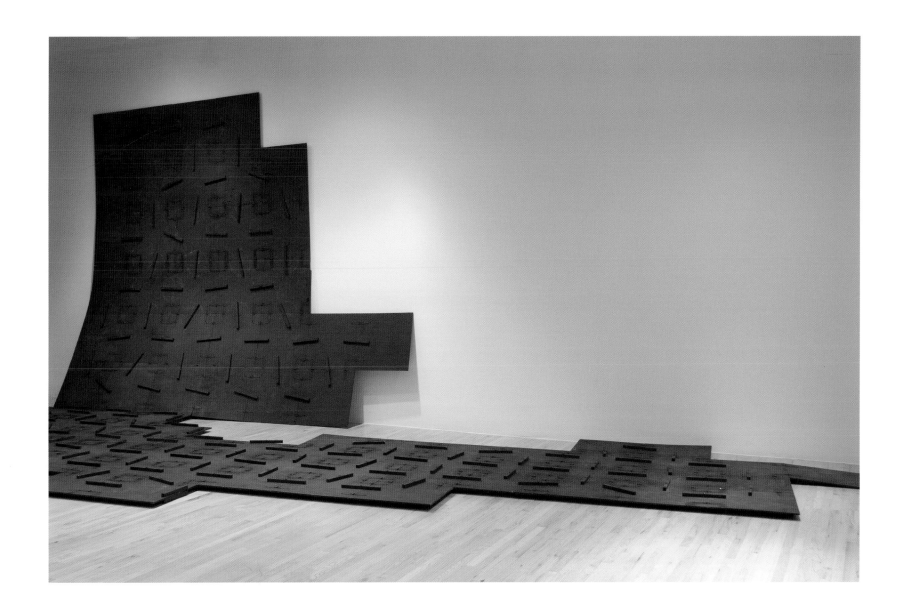

Carla Klein

2009–10 Lift Ticket: *Untitled* (2009)

I was incredibly happy to participate in the ski lift-ticket project, not in the least because I was invited to go to ski in Aspen with my boyfriend. As I had never skied before (except for one not-so-successful try), I was kind of eager to go and learn to ski in the Rocky Mountains. How good can it get?

This was a little problem when Heidi asked me to do a painting for a ski lift ticket. I was familiar with wintery landscapes, but not so much with the skiing part of it. So I choose from the photographs I still had from a trip in Sweden taken from a helicopter. I thought these had a similarity with being in a lift, flying over white and somehow unfamiliar and unrecognizable landscapes. Where the "real" world has disappeared into a different one. Where there's a shift of reality, a shift into a different reality, an inhabitable and in principle harsh environment with a pristine beauty and stillness to it. I made four different paintings and let Heidi make the decision which was most suitable for a ticket. I then made the layout as if it was a work in itself.

Carla Klein and Leon Duenk skiing in Aspen

Studies for the 2009–10 lift ticket in the artist's studio

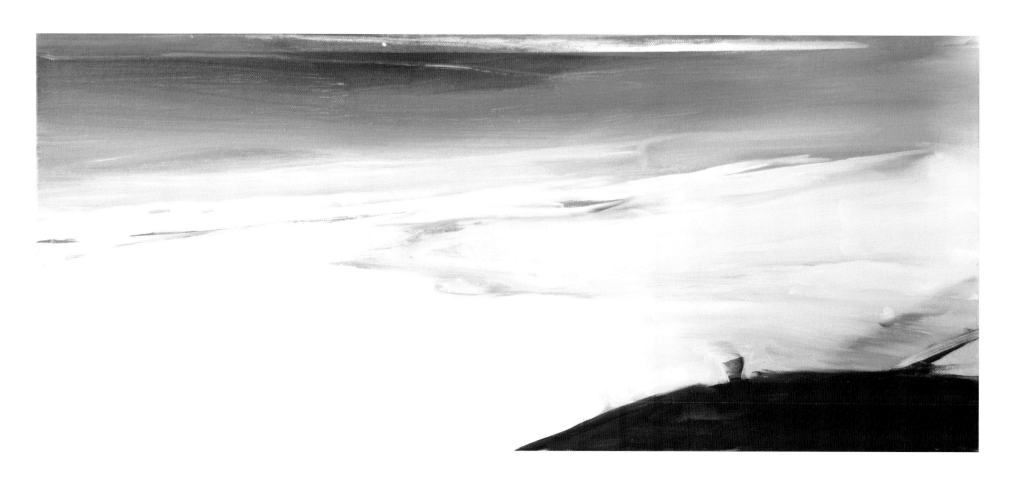

2009–10 lift ticket
Opposite: Carla Klein, *Untitled*, 2009

We flew to Denver and had to make an enormous detour as some rocks had fallen over the direct road to Aspen, and so it was really late when we arrived. Luckily the staff of the museum had left instructions for the hotel, so they had left the keys for the room outside of the hotel door. Where can you find such a belief in human goodness these days? So we were very happy, although the room was a bit different than expected. The next morning I was asking about the room, and what turned out? We slept in the wrong room in the wrong hotel and took somebody else's key! I did wonder the night before why there was a different name on the envelope with the keys, ha ha.

The actual learning how to ski was great. The teachers were really good; they took everybody step-by-step to the next level and that made us really confident and helped us to enjoy the experience a lot. After three days we thought we almost mastered the skills and skied with all the other skiers just off the mountain, and it felt great!

Carla Klein at the Create Your Own Lift Ticket workshop in Snowmass, 2010

What I also enormously liked were the little children dressed up with strange helmets who flew off the mountain in groups of five. Some of them made their own ski lift ticket on a nice warm and sunny afternoon at an event organized by the Aspen Art Museum. It's really great that the museum is so involved in bringing art and fun together!

—Carla Klein

Carla Klein was born in Zwolle, Netherlands, in 1970. Her solo exhibitions include *A reconstruction of random timeline*, Tanya Bonakdar Gallery, New York (2009); World Class Boxing, Miami (2008); and *Carla Klein/MATRIX 218: Scape*, The Berkeley Art Museum and Pacific Film Archive, California (2005); and her work has been featured in such group exhibitions as *I promise to love you*, Kunsthal Rotterdam, The Netherlands (2011); *Seeing the Light*, Tanya Bonakdar Gallery, New York (2008–09); *Radar: Selections from the Logan Collection*, Denver Art Museum (2006); *Vanishing Point*, Wexner Center for the Arts, Columbus, Ohio (2005); and *Delay*, Museum Boijmans van Beuningen, Rotterdam (2004).

Jennifer West

Guest Artist | Bud Light Spring Jam 2010
Shred the Gnar Full Moon Film Noir (2010) film screening
Friday–Sunday, March 26–28, 2010 | Aspen

Shred the Gnar Full Moon Film Noir film production
Kick Aspen Big Air competition, March 19, 2010 | Aspen Mountain
Fallen Friends Memorial, March 20, 2010 | Aspen Highlands

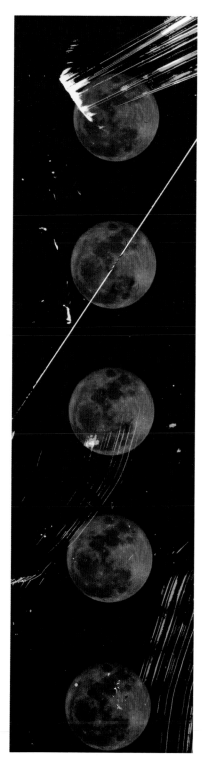

The title of the work that I made in Aspen with the Aspen Art Museum and the Aspen Skiing Company is *Shred the Gnar Full Moon Film Noir.* The rest of the title is *35mm film print and negative shredded and stomped on by a bunch of Snowboarders and a few Skiers getting ginormous, catching air, during Aspen Big Air Competition and Fallen Friends Event, marked up with blue course dye, sprayed with Diet Coke, Bud Light & Whiskey, taken hot tubbing with Epsom salts, rubbed with Arnica, K-Y Jelly, butter and Advil, full moon shot by Peter West.* It's five minutes and nine seconds.

To describe how the project worked: when I was asked to do the project, I immediately thought, upon doing some research, about using the image of a full moon as a way to harness the history of snowboarding and especially the particular moment when snowboarding was still not allowed on the ski slopes, and snowboarders were known to climb up parts of the slopes at night and snowboard during the night hours. That's where I came up with the idea for the image of the moon, and it was also directly tied into the idea, in both snowboarding and skiing, of rotation when doing jumps. We had just come off the Winter Olympics at that time, with Shaun White and all of the really amazing snowboarding and skiing events that had happened there.

I shot the image of the full moon in Los Angeles with Peter West, made a film print to take to Aspen, and with the help of the Aspen Skiing Company and the Aspen Art Museum, set up two different events where the actual film print would be impacted and shredded upon and marked up by snowboards and skis. One of the events was a big air competition. During that event we put a lot of filmstrips down at the bottom of the jump so the snowboarders and skiers would go over them at the very end. Once they understood what was going on, it was really great because they started, on their own, purposefully shredding over the film negative and film print. I have some great still images of snowboarders and skiers holding up the film print to see what the shred marks had done to the actual film emulsion down at the bottom of the jump. So I think they understood really well what was going on. As I hoped, the snowboards and skis cut into the yellow and green layers of the film print producing detailed scrapings very visible to the eye.

The next event was the next day, and that's called the Fallen Friends Memorial. Some of the same people from the night before also came to this event. This was a fund-raiser where people dressed in costumes; it was thematic and more fun and spontaneous. For that event, we also set up film in big piles at the end of the run, and because people were more relaxed, there was a lot of spontaneous shredding of the film. One of the snowboarders started jumping on the film and sprayed it all over with Diet Coke® that he was carrying around as part of his costume; others were falling on top of the film, and we got a woman in costume to tape film to the bottom of participants' snowboards to shred it. The announcers were announcing what I was trying to do to the film, and people were really getting into shredding it as much as possible.

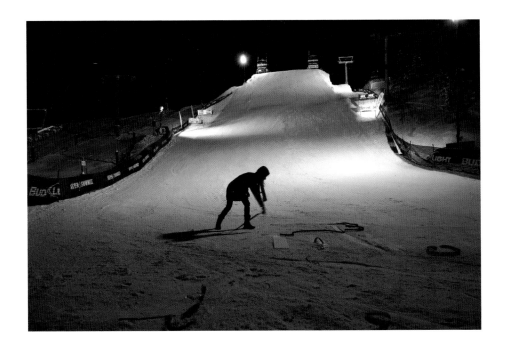

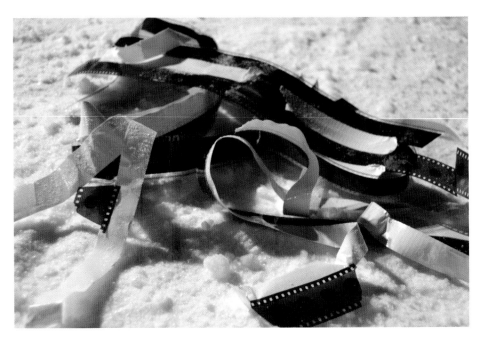

Shred the Gnar Full Moon Film Noir production stills

Kick Aspen Big Air competition, Aspen Mountain, 2010

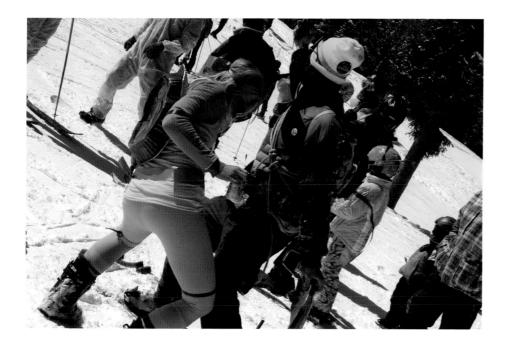

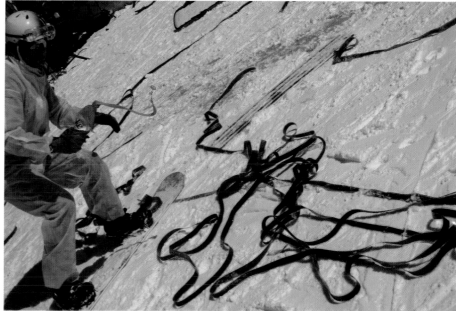

Fallen Friends event, Aspen Highlands, 2010

Artist Jennifer West

So a lot of the substances that are on this film celluloid came directly from the spontaneous actions of the event participants, like the film being sprayed with Diet Coke and Bud Light® at the Fallen Friends event. Other materials also came from research in advance. I was able to secure some of the blue course dye that's used along the edges of the slopes during the competitions, and that established one of the dominant characteristics of how this film looks. I used the dye to paint a blue line along the filmstrips — so there are splashes of blue over the image of the full moon. I got some of that actual dye from one of the contacts from the ski company, who was very helpful.

The film has evidence of all these different things that evoke the experience of the events and the culture around them. For example, I was fascinated by the announcer's use of snowboard and ski slang — an entirely invented language — and I incorporated a few of those terms into the title of the film, such as "getting ginormous" and "stomped on." I wanted the film to also evoke the personal and very bodily side of skiing and snowboarding. That's why I took the film hot tubbing there in our hotel in Aspen. I put aspirin and arnica on the film as well as evidence of how your body feels after a day of doing this.

It was quite amazing how the final film lived up to my expectations, especially the deep groove marks and evidence of shredding. Parts of it were destroyed altogether, but the snowboarders' and skiers' markings were really quite beautiful and stunning and really suggested this idea of going to the moon or being able to rotate around the moon. Actually, cutting into the celluloid in this very physical kind of way also relates to an interesting idea about recording this experience through the actual markings of the snowboards and skis rather than through the images of these people. It's an interesting way to think about recording time.

There were two things that additionally accompanied the film. One of them is a video document. On YouTube there is a short document of all of the snowboarders and skiers shredding over the film, so there's this relationship between those two things. I think of snowboarding, especially, and skiing as being really involved in image-making. The snowboarders made all of their own early videos and that really proliferated the sport in such an intense way, similar to skateboarding, with both still photographs and also with the moving image. There's a connection, too, between image-making and how the sport's popularity today comes through that.

This particular document is interesting because it shows an entire other side to the project. You get to see everyone doing these things, and then you have that in relationship to the finished film, which is shown in an art context rather than on this video, which is allowed to circulate all over YouTube and be a part of the YouTube culture. The great thing is that some of the snowboarders, their relatives, and other people have commented about the performances on the YouTube video. Part of what really gives me impetus as an artist is to be able to tie in different kinds of audiences into this kind of filmmaking, which is rather obscure.

In addition to the film itself and also the video document that's on YouTube, there's a third part in relationship to the whole project: the publication of a booklet of images in black and white, which are the production stills of all of the snowboarders and skiers as they're shredding and doing their big-air jumps and close-ups of the film emulsion being shredded. This publication was produced by the museum and given out for free to people at the screening event that was held during spring break.

So you have still images and their relationship to photography with snow-boarding and skiing, which is such an important element. Also, you have these different ways of knowing something else about the film, which was shown in this art context, and the kind of stories circulating around it. In the spirit of 1990s 'zine culture, the idea was to give these away to anyone who came by to see the film. It was this other way you can know the film.

— Jennifer West

Born in Topanga Canyon, California, Jennifer West lives and works in Los Angeles. Her solo exhibitions include presentations at MARC FOXX, Los Angeles, and Vilma Gold, London (2011); Contemporary Art Museum, Houston (2010); Transmission Gallery, Glasgow, Scotland (2008); Art Basel 39, Switzerland (2008); and White Columns, New York (2007). West's work has been included in group exhibitions at the Schirn Kunsthalle Frankfurt and Seattle Art Museum (2010); Institute for Contemporary Art, Philadelphia, and Cubitt Art Gallery, London (2009); Aspen Art Museum, Colorado, and *ARTTLV 08*, Tel Aviv Museum of Art (2008); Tate St. Ives, Cornwall, England; CAPC musée d'art contemporain de Bordeaux, France; Henry Art Gallery, Seattle; The Drawing Center, New York; and Museum of Contemporary Art, Detroit (2007).

Mark Wallinger

Exhibition: *Restless Empathy*, May 21–July 18, 2010
Aspen Art Museum and Aspen

AMERIKA

Amerika, du hast es besser
Als unser Kontinent, der alte,
Hast keine verfallenen Schlösser
Und keine Basalte.
Dich stört nicht im Innern,
Zu lebendiger Zeit,
Unnützes Erinnern
Und vergeblicher Streit.

Benutzt die Gegenwart mit Glück!
Und wenn nun Eure Kinder dichten,
Bewahre sie ein gut Geschick
Vor Ritter-, Räuber- und
 Gespenstergeschichten.

Johann Wolfgang Goethe
(Translated by David Platt)

America, you've got it better
Than our old continent. Exult!
You have no decaying castles
And no basalt.
Your heart is not troubled,
In lively pursuits,
By useless old remembrance
And empty disputes.

So use the present day with luck!
And when your child a poem writes,
Protect him, with his skill and pluck,
From tales of bandits, ghosts
 and knights.

You may be familiar with the story of how, upon independence, German came within one vote of becoming America's official language instead of English. It never happened.

Goethe would have been mindful of the Monroe Doctrine when he wrote "Amerika": a policy introduced on December 2, 1823, that defined the separate spheres of influence for the Americas and Europe, noncolonization, and nonintervention. It was designed to signify a clear break between the New World and the autocratic realm of Europe.

Don't take a backward look, Goethe seems to be saying. Imagine when the future was an open book, empty of content. (We leave the native people out of the argument.) To make a new history, leave the old world clogged and hidebound, its people yoked by tradition, superstition, and duties they would never seek, given the chance.

Amerika was the name Max Brod gave to Kafka's unfinished novel, published posthumously in 1927. Kafka was not the first, nor would he be the last, to write about a country he had never experienced.

1949. Walter Paepcke organizes the convocation for the bicentenary of Goethe and the creation of the Aspen Institute. The liberal ideals it continues to extol are a favorite target for right-wing conspiracy theorists.

During the Cold War, the Monroe Doctrine was applied to Latin America by the framers of US foreign policy. When the Cuban Revolution established a socialist government with ties to the Soviet Union after trying to establish fruitful relations with the US, it was argued that the spirit of the Monroe Doctrine should be again invoked, this time to prevent the further spreading of Soviet-backed Communism in Latin America.

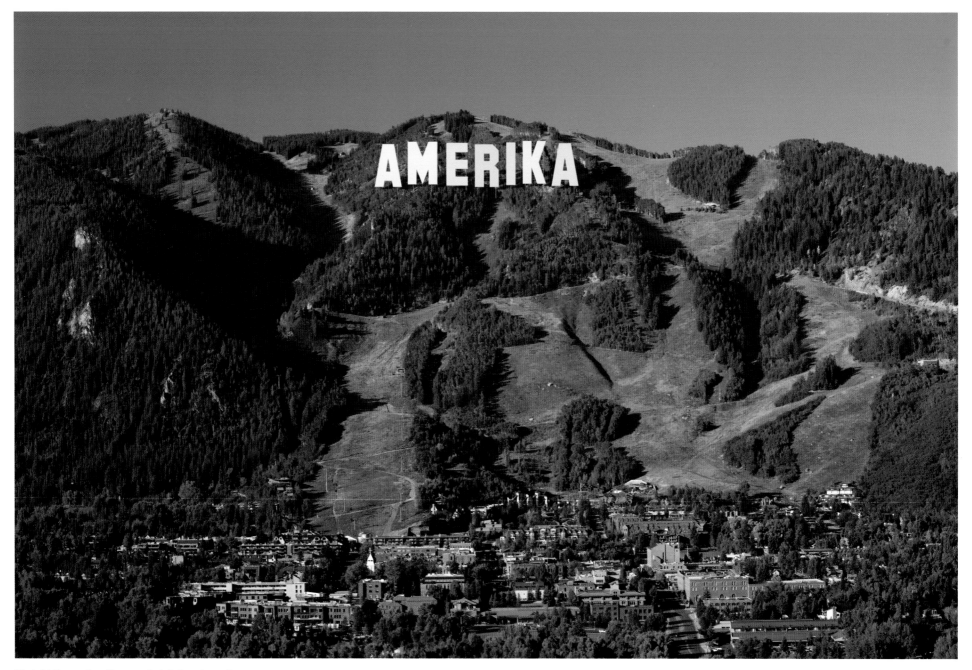

Mark Wallinger, *Amerika*, 2010. Installation views, Aspen.

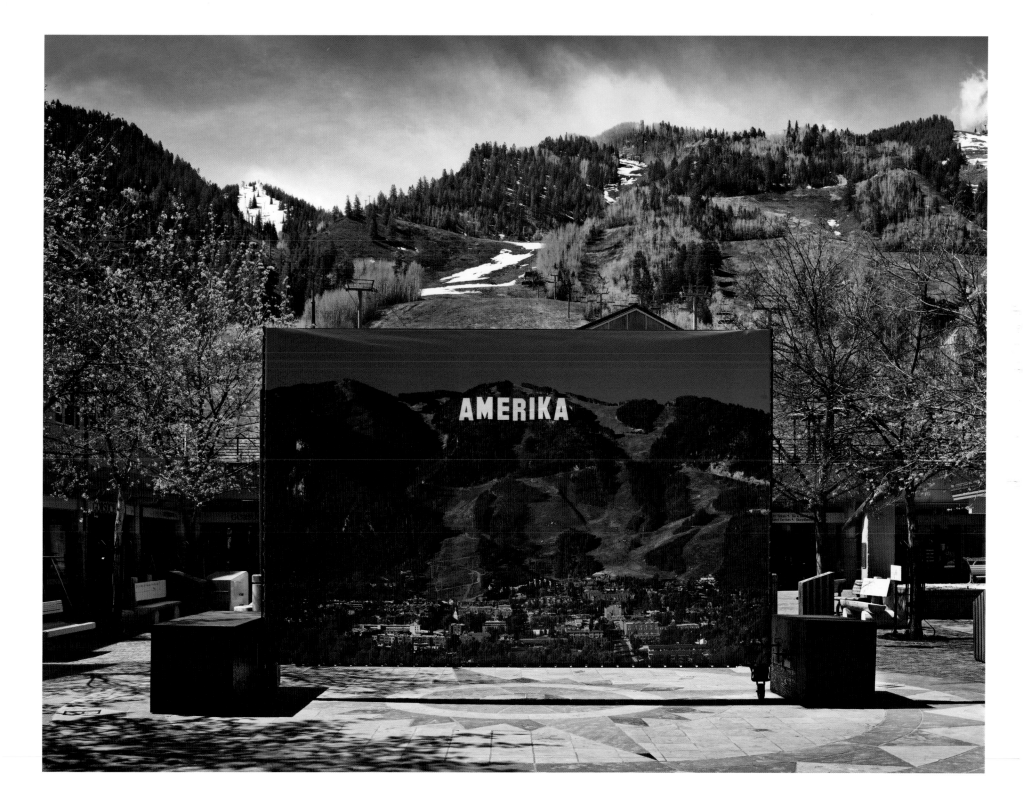

AMERIKA. That K is bothersome. K is for Kafka and Klan and old enmities—the Cold War from the Old World. To misspell something that has its precious existence as an idea as much as a continent. It could never happen here, surely. Even an old ABC miniseries demonstrated the impossibility of imagining Amerika ever existing.

Try to imagine a different future.

O, mein Amerika, mein Neufundland . . . Voll Nacktheit! Alle Freuden sind auf dich . . .

I have read a very convincing case for the idea that the Yellow Brick Road and the silver shoes Dorothy takes from the dead witch are an allegory of the nineteenth-century disputes about bimetallism and the gold standard.[1] Even the name Oz would stand for an ounce of free silver on the golden path to a free coinage. (The shoes were changed to ruby in the 1939 film.) Jack Zipes has argued convincingly that Baum's fourteen novels about the land of Oz are a criticism of the America of his time, its machines, its commodities, its politics. Oz, with its kind witches and female powers, is the utopia that stands against, not for, the United States.

The way the story is told confirms the idea that it is firmly controlled by beliefs and meanings. Baum said that he was dispensing with the old world of fairy tales. This is from his 1900 introduction to *The Wonderful Wizard of Oz*:

Yet the old-time fairy tale, having served for generations, may now be classed as "historical" in the children's library; for the time has come for a series of newer "wonder tales" in which the stereotyped genie, dwarf, and fairy are eliminated, together with all the horrible and blood-curdling incidents devised by their authors to point a fearsome moral to each tale. Modern education includes morality; therefore the modern child seeks only entertainment in its wonder-tales and gladly dispenses with all disagreeable incidents.[2]

"*Amerika, du hast es besser,*" Goethe wrote, comparing new, clean America to the old continent, with its decaying castles and grim tales.

—Mark Wallinger

Notes
1. A.S. Byatt, "There's something about Alice," *Guardian*, February 27, 2010.
2. Frank L. Baum, *The Wonderful Wizard of Oz* (Chicago and New York: George M. Hill, 1900).

Born in 1959 in Chigwell, United Kingdom, Mark Wallinger currently lives and works in London. He has had solo exhibitions at the Aargauer Kunsthaus, Aarau, Switzerland (2008); Tate Britain, London, and Kunstverein Braunschweig, Germany (2007); Museo de Arte Carrillo Gil, Mexico City (2006); and Neue Nationalgalerie, Berlin (2004). He represented Britain in the 49th Venice Biennale (2001), and in 2007 he participated in Skulptur Projekt Münster and was awarded the Turner Prize. His installation *Amerika*, depicted here, installed at the base of Ajax (Aspen) Mountain, was featured in the Aspen Art Museum's 2010 exhibition *Restless Empathy*.

Amerika, du hast es besser
Als unser Kontinent, der alte,
Hast keine verfallenen Schlösser
Und keine Basalte.
Dich stört nicht im Innern,
Zu lebendiger Zeit,
Unnützes Erinnern
Und vergeblicher Streit.

Benutzt die Gegenwart mit Glück!
Und wenn nun Eure Kinder dichten,
Bewahre sie ein gut Geschick
Vor Ritter-, Räuber- und Gespenstergeschichten.

America, you've got it better
Than our old continent. Exult!
You have no decaying castles
And no basalt.
Your heart is not troubled,
In lively pursuits,
By useless old remembrance
And empty disputes

So use the present day with luck!
And when your child a poem writes,
Protect him, with his skill and pluck,
From tales of bandits, ghosts and knights.

Lars Ø. Ramberg

Exhibition: *Restless Empathy*, May 21–July 18, 2010
Aspen Art Museum and Aspen

Dear Mrs. Thompson:

I understand that you have been in contact with Heidi Zuckerman Jacobson from the Aspen Art Museum regarding my proposal to install a conceptual artwork in and around Aspen as part of the *Restless Empathy* exhibition.

After a visit to Aspen in October 2009, I became quite interested in Hunter S. Thompson. I really admire his work. In addition to his great career as a journalist, his engagement in politics—like running locally for Sheriff in Pitkin County—resonated strongly with me and provided the context for celebrating him in a new work for Aspen.

During my stay, I was especially intrigued by the benches in downtown Aspen, which are used as private memorials with engravings. Unlike traditional memorial markers, these can be sat on and used as a space for contemplation.

I decided to use this as the platform and social context for my new work. My proposal consists of eight benches installed in different places in Aspen, including the Cooper Avenue mall, Gondola Plaza, the top of Aspen Mountain, and the grounds of the Aspen Art Museum. The new benches will be integrated with the existing ones, though set off by their high-end carpentry and machine-engraved text filled with gold leaf.

My original idea was to publish Mr. Thompson's last words. However, I understand and deeply respect your reservations. I am pleased to learn of your invitation to share some alternative quotes. I really appreciate your engagement. I would love to include you in the process of creating the work. My goal is to create a sculpture that respects Mr. Thompson and the family as a memorial through his critical, frank, and emphatic voice, and as a conceptual work wanting to address critical thinking in general.

I am very happy to learn from Heidi that you like the concept of creating this temporary memorial, and I would love to continue the dialogue. I look forward to hearing from you.

With my best regards,

—Lars Ø. Ramberg

Lars Ø. Ramberg's sculptural interventions in public space are intended as a platform to change viewers' relationships with one another and their surroundings. With an incisive wit, his works examine the often unquestioned routines, customs, and perspectives of a given place, thereby revealing rich meaning in apparently insignificant situations. Ramberg was born in 1964 in Oslo, Norway, and currently lives and works in Berlin. In addition to the Aspen Art Museum's *Restless Empathy* (2010), his work has been included in numerous group exhibitions, among them the 52nd Venice Biennale (2007); *Dreamworks*, Rotterdam Film Festival, the Netherlands (2004); *Where am I now?* Museum of Contemporary Art, Oslo, Norway (2002); and *Gluck & Casino*, Kunsthalle Dresden, Germany (2000).

Lars Ø. Ramberg, *Benchmark (Memorial to Hunter S. Thompson)*, 2010. Installation views in Aspen (p. 94) and on Ajax Mountain (p. 95).

94

Walter Niedermayr

2010–11 Season Pass: *The Aspen Series* 72/2009 and 77/2009 (2009)
Exhibition: *The Aspen Series*, November 2010–April 2012
Aspen Skiing Company locations in Aspen and Snowmass

The changing view of landscape and conception of nature over time

Which view and conception did the Ute Indians have of the landscape around Aspen, surroundings that had, after all, formed their living environment for eight centuries until they were forced onto reservations? The city of Aspen got its name around 1878, back when the first mines were founded there. Before that, the landscape was named after the Castle and the Maroon Creek Valleys, the area occupied by the Ute people during the summer months. The native people believed that the Great Spirit created the landscape and nature and allowed the people to use them. From this we can conclude that the Ute people must have regarded the landscape with respect.

The first shift in view and change in attitude in relation to the landscape came with the advent of mining in these valleys. It led to a utilitarian view of the landscape through the white settlers, an exploitation of nature and resources.

A further shift in view came with the decline of mining around 1936, a development that coincided with the rise of winter sports tourism. In 1941 the first National Skiing Championships were held in Aspen, and the Aspen Skiing Corporation was founded along with the opening of the first ski lift in 1946. This marked the beginning of Aspen's growth into one of the most modern and posh ski resorts in the world. The perception of this alpine space, in particular of the landscape and nature, continues to be committed to the conventional image: the antipodal relation between man and nature. Here unspoiled and veritable nature; there the already tainted antithesis, altered by approximation and use, vanished.

These opposites are constantly evoked and used in the perception and depiction of nature. Nature becomes romanticized, and in doing so we alienate it by conceiving it as a dreamlike backdrop or stage setting in which the real is only fleetingly perceived, or perceived as the other and the good world. This view is conveyed via artistic media, initially through painting, later through photography. In art, photography with its ostensibly veritable view of the landscape has meanwhile supplanted painting. But it has become clear, at least since the advent of digital photography, that it is also possible for these images to be staged. The distinction against painting as an imagining art no longer exists. It is not only the medium of photography that is unsettling, however, but the motif as well.

In this context I would like to elucidate my work method using *Aspen 25/2009* (p. 103) as a reference. The two-part diptych is rendered in cool monochrome. The detail of the landscape framed in the right image is similar to that of the left image, except that in the former the horizon is lower and thus less landscape is visible in the bottom part of the photo. Moreover, it is also shifted slightly to the right. The framing of the detail is determined at the moment of taking the picture in order to produce an apparent sense of the two images belonging together. Two real image details, so to speak, are brought together in a logical, visually constructed context. Furthermore, through a minimal alteration in the lighting situation and the positioning of the people who are visible as specks, the left image appears slightly different from the right.

The depiction of the landscape itself in the two photos is regarded by most people as a so-called natural landscape, which isn't actually correct because it is in fact a cultural landscape that has been modified and constructed by humans to serve their purposes; one might also describe it as nature that has been custom-formatted to meet the needs of the tourist industry.

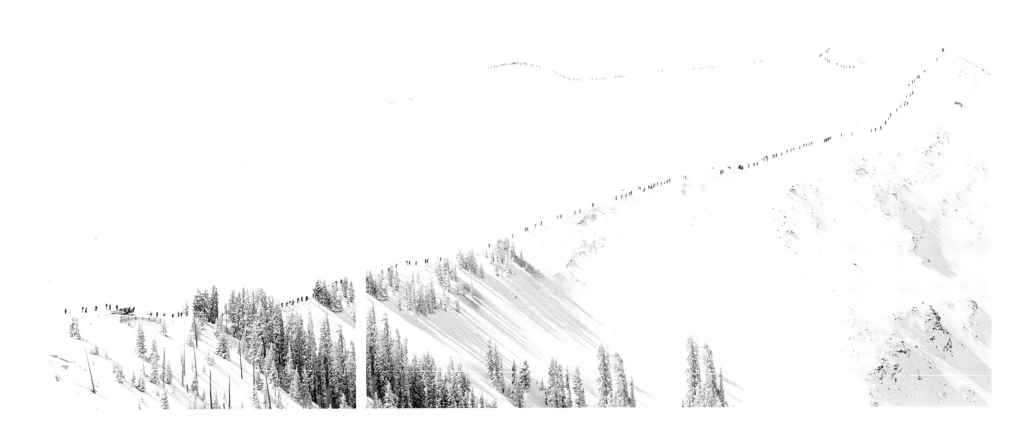

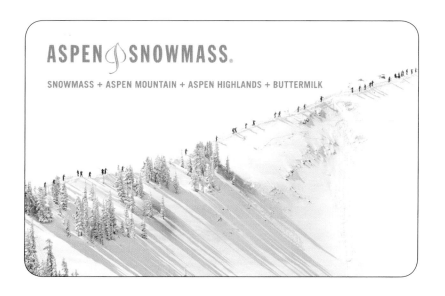

2010–11 season pass
Opposite: Walter Niedermayr,
Aspen Series 72/2009, 2009

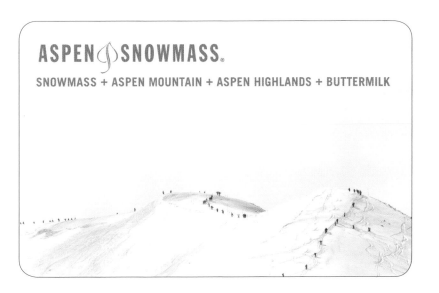

2010–11 season pass
Opposite: Walter Niedermayr,
Aspen Series 77/2009, 2009

What also makes this view unsettling is the change from the appearance of photographs and color images as they are engrained in the consciousness of the beholder to images of brightness and color density. In addition, by taking away image density I reduce spatial depth, which tends to produce a planar quality of the image.

With the technical means of photography, I seek to contradict the medium's purported claims to reality and make reference to the openness and bound-lessness that can lie before and behind the images. The work oscillates between the beautiful illusion of a so-called reality and the reality of the image. It is aimed at revealing the medium's mechanisms as well as placing demands on and increasing the precision of perception.

The two details printed on the lift tickets come from a two-part and a three-part work—one in black-and-white and one in color. Both details show the ascent to Highland Bowl and are part of the triptych *Aspen 72/2009* and the diptych *Aspen 77/2009*. They were created based on the work concept described above and could not as such, since they consisted of multiple parts, be used in their entirety for the ticket. This makes reference to the fundamental difficulty of using these serial works for illustrative or other purposes.

—Walter Niedermayr

Walter Niedermayr was born in Bolzano, Italy in 1952, where he lives. His work was the subject of a traveling retrospective *Walter Niedermayr: Civil Operations* (in 2003 to Museum der bildenden Künste Leipzig, Kunstverein Hannover, and Württembergischer Kunstverein Stuttgart in Germany and Kunsthalle Wien, Vienna; and in 2004 to MUSEION, Museum of Modern and Contemporary Art, Bolzano). His solo exhibitions include Galleria Suzy Shammah, Milan (2011, 2008); Robert Miller Gallery, New York (2009, 2006); Galerie Nordenhake, Stockholm/Berlin (2009, 2007); and Centre pour l'image contemporaine, Geneva (2000). His work has been shown in such group exhibitions as *Blink! Light, Sound & the Moving Image*, Denver Art Museum (2011); *Tokyo Art Meeting (II) Architectural Environments for Tomorrow*, Museum of Contemporary Art Tokyo (2011); *Remote Proximity—Nature in Contemporary Art*, Kunstmuseum Bonn, Germany (2010); *Manifesta 7*, Bolzano (2008); and *Tourist's Tale*, Center for Contemporary Art, Aarhus, Denmark (2007).

Commissioned by Paula and Jim Crown, *The Aspen Series* was organized and curated by Christopher Byrne of Dallas. With Byrne's help, Walter Niedermayr made several visits to Aspen in 2009; the result of his work is 42 photographic compositions and a video titled *Downhill*, as well as digital murals. A selection of the work is on view November 2010–April 2012 as part of a multisite exhibition in Aspen and Snowmass Village.

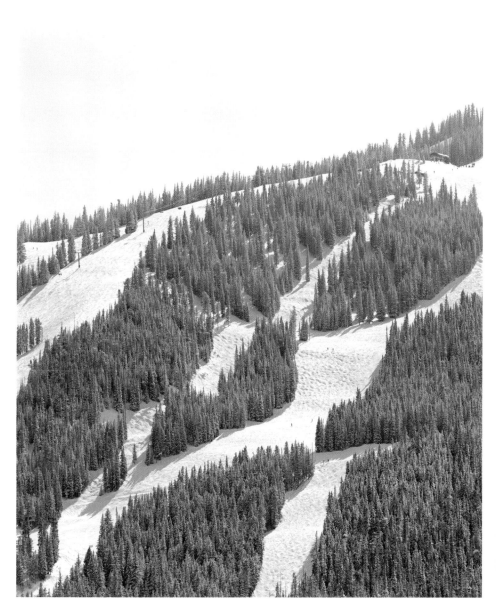

Walter Niedermayr, *Aspen Series 25/2009*, 2009

Mamma Andersson

2010–11 Lift Ticket: *Sleeping Standing Up* (2003)
Exhibition: December 10, 2010–February 6, 2011 | Aspen Art Museum

It's been long now.
Years go by, days turn into months and years.
At the time when I made the painting *Sleeping Standing Up* (2003)
 I was thinking about time.
What is time?
What's left of us when we have had a moment of life on earth?

Then, just before I began working on the painting: One evening I was laying
 in the sofa watching a documentary about Finnish (Swedish-speaking)
 author Willy Kyrklund (1921–2009).
Really I don't remember that much about the actual film.
But one scene got stuck on my mind. It may be so that it over time has both
 grown stronger and become much different.
What do I know?

Willy Kyrklund, accompanied by the film crew, had gone back to the place
 where he was brought up (a village named Harlu in Karelen in the eastern
 part of Finland, invaded by the Soviet Union in 1940.)
This was the first time he revisited these grounds. He found the road by which
 his house once was, but the house itself was long since gone.
He sat down on a big stone, on what was once land belonging to his family.
 He said (the way I recall it):
When I was a child, I often used to sit here with all my life in front of me.
 Now I sit here again with life behind me.

My painting shows a piece of woodland. In the background you see marks/
 reflections from windows.
Windows that once gazed from a sanatorium (hospital for people suffering
 from TB), a view towards freedom and longing.
The same windows also gazed inside towards sickness, isolation, and death.
 In reality this sanatorium was deep in the woods in the vicinity of my
 father's home village.
My father was born in 1918; he has now been dead for twenty years.

— Mamma Andersson

Born in 1962, Mamma Andersson is based in Stockholm, Sweden. Her recent
exhibitions include a critically acclaimed mid-career survey at Moderna Museet in
Stockholm (2007), which traveled to Taidehalli Kunsthalle, Helsinki, and Camden
Arts Center, London; Grafikens Hus, Mariefred, Sweden; and the Douglas Hyde
Gallery, Dublin. Her work was featured in the exhibitions *Who is sleeping on my
pillow*, David Zwirner, New York (2010); *Contemporary Commentaries*, National-
museum, Stockholm (2009); and *Devil May Care* at the Nordic Pavilion at the
2003 Venice Biennale. In 2006 she was the recipient of the Carnegie Art Award,
with a corresponding exhibition, which traveled extensively through Europe. In
the United States, her work is in the collection of the Dallas Museum of Art; the
Hammer Museum, Los Angeles; The Museum of Contemporary Art, Los Angeles;
and in Sweden, Göteborgs Konstmuseum, Malmö Konstmuseum, and Moderna
Museet. Her 2010–11 exhibition at the Aspen Art Museum included *Sleeping
Standing Up* (2003), pictured here and featured on the 2010–11 lift ticket.

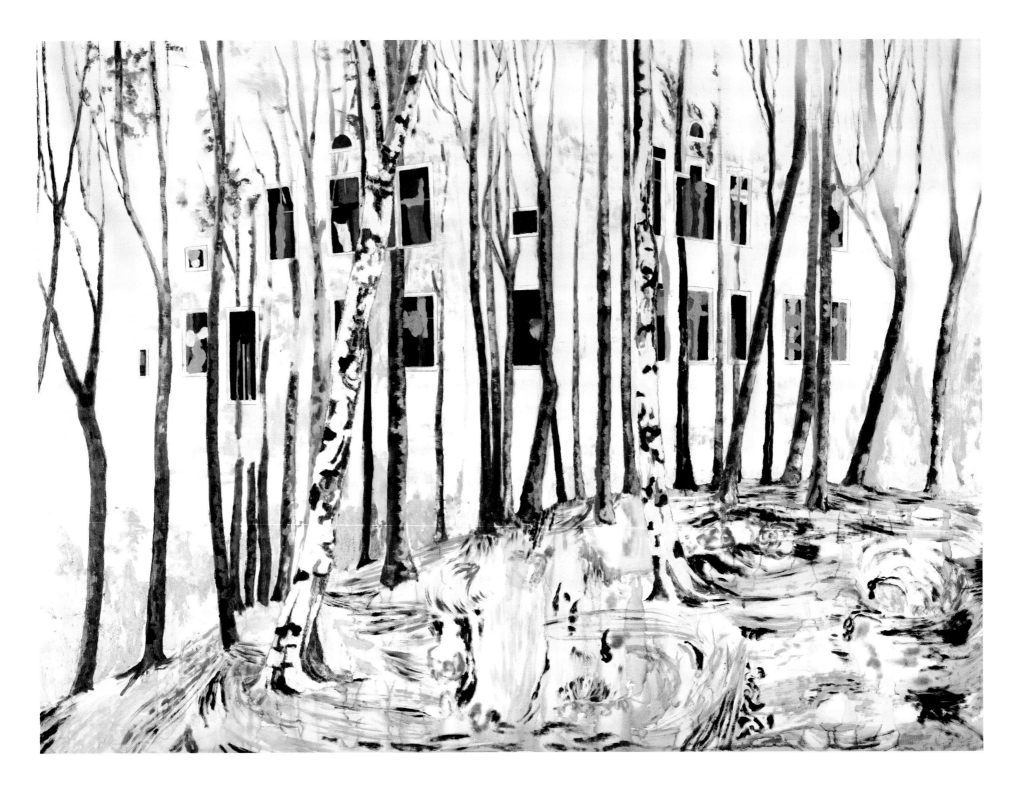

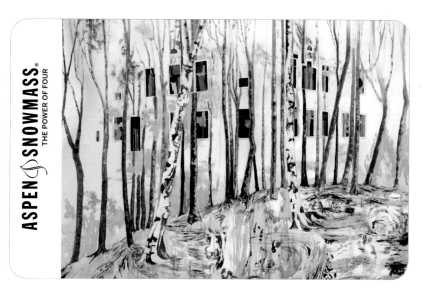

2010–11 lift ticket
Opposite: Mamma Andersson,
Sleeping Standing Up, 2003

Mamma Andersson (exhibition). Installation views, Aspen Art Museum, 2010.

Susan Philipsz

Sound installation: *White Winter Hymnal* (2010)
December 10, 2010–February 21, 2011 | Snowmass Mountain

The following is an excerpt from a December 8, 2010, interview by Heidi Zuckerman Jacobson.

HEIDI I wanted to start off by talking about your practice in general and giving people a context for the work that you do.

SUSAN Well, just to say a little bit about where I studied. I'm from Glasgow, but I studied in Dundee. I specialized in sculpture. Then, I went on to do my MA, and it was when I went on to do my MA in Belfast that I started working with sound.

The reason for that was I'd always liked singing, ever since I was a kid. When I was in Belfast, I started thinking about the physicality of singing being quite a sculptural experience—what happens when you project sound into space, how it can define the room that you're in, and how you become aware of your inner body space. So I started thinking about sound in sculptural terms. It seemed like a natural progression to go from working with sculpture to working with sound sculpture, if you like, and a lot of people do refer to me as a sound sculptor.

I've been working with sound ever since I graduated from my master's in 1995. I work not only within the museum and gallery context, but also a lot in public space. It's very different to work in a public, outdoor context than it is in a controlled environment, such as a gallery or the Aspen Art Museum. I enjoy working with both.

H So when you are invited to do a project, how important to you is the space in which your work will be presented? How does that factor into what you'd like to present?

S It's really important; it always begins with the place. If I'm invited to make a new work, I come and do a site visit and see the place. That's where the inspiration comes from. It's things like the architecture, the atmosphere, the acoustics of the particular place that I'm interested in. For instance, the work *Lowlands* (2010), for which I was nominated for the Turner Prize, was in a very special place in Glasgow, where three bridges cross the River Clyde. The three bridges are really fantastic; they're right in the city center, and they say so much about the city. But underneath the bridges is the dark underside of Glasgow. It's very atmospheric and has incredible acoustics. That seemed like the perfect home for *Lowlands*.

H There have been a couple of different circumstances where bridges seem to factor into your installations, like the one in Aspen. The first time that I remember experiencing your work was in Münster, where the work *The Lost Reflection* (2007) was installed under a bridge as well. What do you think is the magnet for your work with bridges? Is it the acoustics or the shape?

S The acoustics can be really special, like in Münster. And also the water, I was drawn to the water in Münster. The Lake Aa is right in the center of the city. I was invited to come do a site visit. I was given a map and a bike and told to go on my way. So then, as I was cycling down to the bridge, everything changes. The atmosphere changes. It was a beautiful, sunny day, but then you're under the bridge. And the sound changes; it becomes darker. So I stopped, and I looked across the bridge from underneath, and it really did seem like you were looking into a mirror because the people at the other side were looking back at you. Also the architecture of the bridge looks like it's split in two. There's this doubling effect that's really strange.

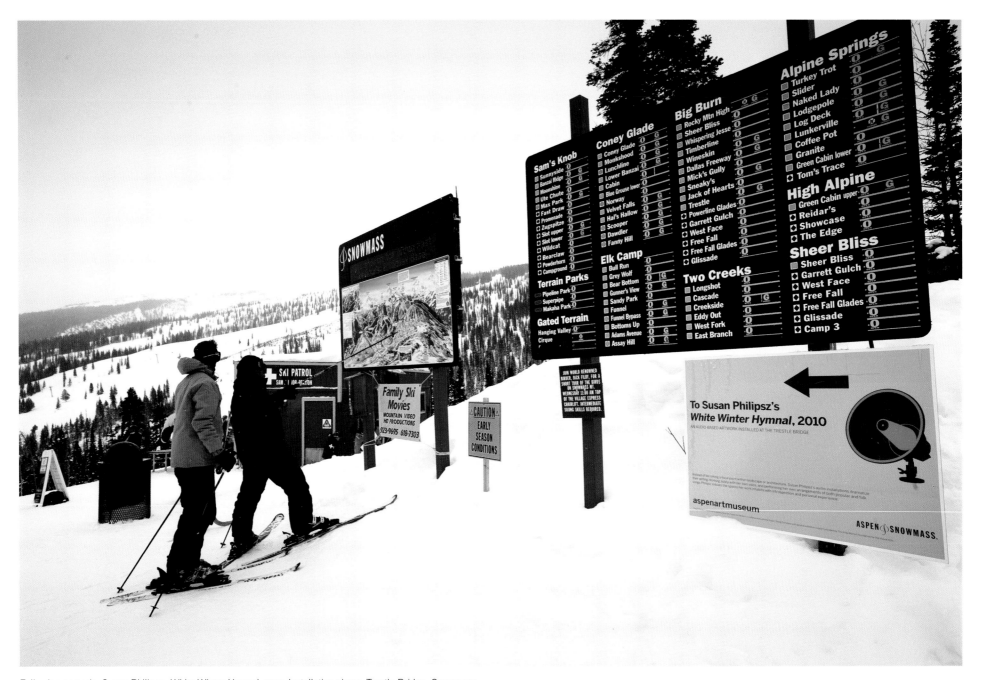

Following spreads: Susan Philipsz, *White Winter Hymnal*, 2010. Installation views, Trestle Bridge, Snowmass.

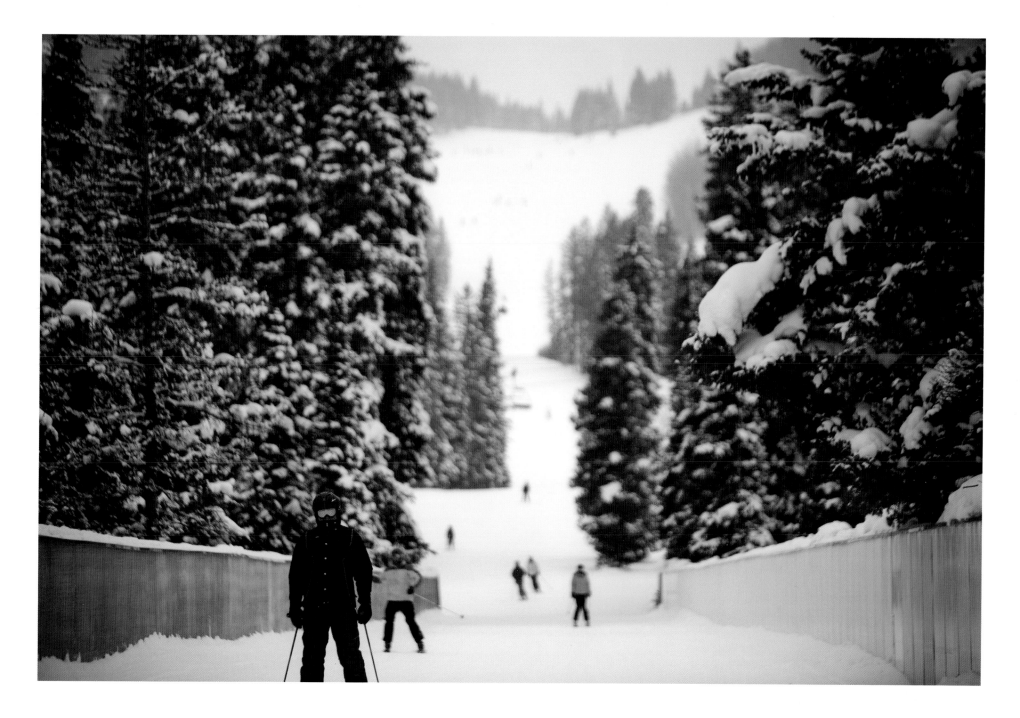

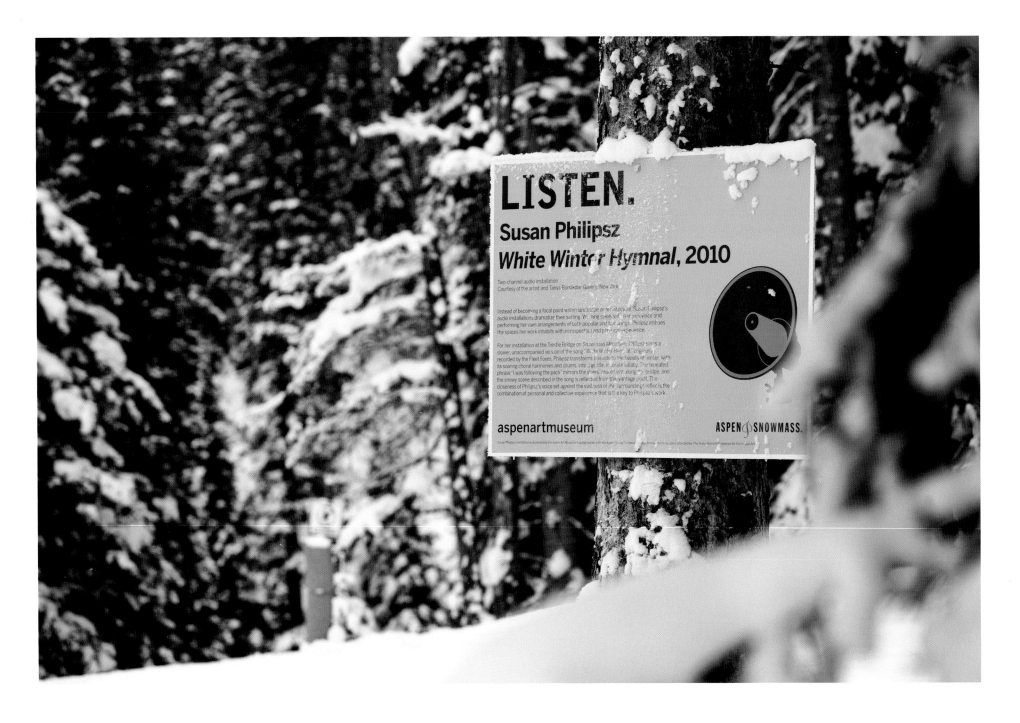

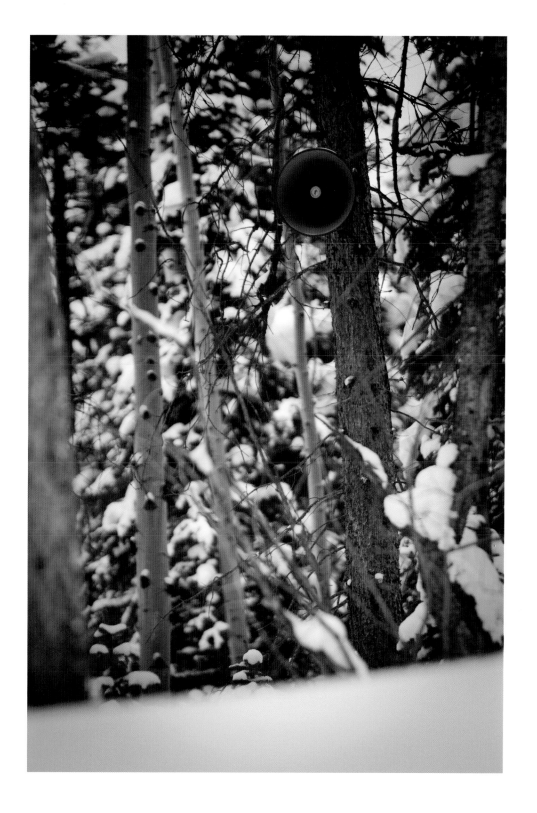

I started thinking about that and also this song from when I was a child, this *barcarolle* (a folk song sung by Venetian gondoliers). I knew it was about two people who called across the water to one another, but I didn't realize then that it was a song written by a German composer, Offenbach. He made it into an opera called *The Tales of Hoffmann* (1881), based on stories by the famous German writer E. T. A. Hoffmann, who wrote stories like "Der Sandmann" (1817) and "Die Doppelgänger" (1821) based on fairy tales. So what a perfect place to do a Hoffmann-inspired work, under a bridge that seems to be looking into a mirror.

So that inspired *The Lost Reflection* (2007), a work that is titled after one of the *Tales of Hoffmann* which tells the tale of the evil courtesan Julieta. She is out in her gondola and she catches site of her reflection in the water. Then her reflection begins to sing to her this barcarolle, so she joins in and she has a duet with herself. So what I've done is recorded myself singing both parts of this barcarolle, the soprano and the mezzo-soprano parts, then had the parts played on speakers installed on either side of the bridge that crosses Lake Aa.

H Is that piece there permanently?

S It is. It was part of the Münster Sculpture Project (Skulptur Projekte Münster) that happens every ten years. The city acquires a couple of works from it. I never dreamed that it could be a permanent installation, but it is. From the responses I get, the people of Münster seem to really enjoy it. But I thought—since it's playing all the time—I didn't want them to get tired of it. So I said, "Let's do it like this: you can do it every Sunday on the hour."

H That's such a poetic thought: the whole thing coming together, and the idea of the mirroring, the singing to yourself, and finding that mysterious space. Oftentimes sound is such an evocative memory. So people know that they can go and find this piece and experience it, but just once a week?

S Yeah. The one thing that I forgot to mention about *The Lost Reflection* is that, in the story, the evil courtesan Julieta seduces Hoffmann by stealing his reflection.

H Interesting. That's just the whole idea then: both recapturing something and anticipating, looking forward to something. So part of your work is very much about the interval between the sound as well?

S That's part of it. I think for those who just happen upon the work unexpectedly, that's part of the experience. But there are also those who are waiting in anticipation. I think the silence is important; you don't want it to be too repetitive.

It's interesting how people respond to the piece. I think when the sound appears suddenly, people become hyperaware of their surroundings. I'm really interested in how sound can define the architecture of a space, but also heighten your sense of yourself in that space. I think that happens more when it's unexpected.

H With regard to your piece here in Snowmass, I think one of the magical elements of your work is the opportunity to get people in a different space: a psychic space, an emotional space, or just a different space than they're used to inhabiting. Take for example the project that you have with Artangel in the city of London. Most of the people who experience that piece probably have been to that same site thousands of times; but by providing this unexpected element, they maybe see something different because they feel something different. How does that emotional response that we sometimes have to the sound of singing factor into the work that you conceive for these locations?

S I think an unaccompanied singing voice, especially one that is clearly not a trained voice, is important. I don't try and clean up the sound of my voice in postproduction, so it's a very human voice. It could be anyone's voice. I think what happens is that everyone can identify with that voice, and then when they hear it, the sound animates the architecture and defines the space, like you say, in a new way. You could be going through Change Alley every day to work, but then to have it filled with sound, you really begin to notice other things that you haven't noticed before. So I'm really interested in how people respond emotively and psychologically. Those are the things that I'm interested in my work.

H You have a very diverse range of songs that you pull from — everything from madrigals to really contemporary pop music. Can you talk a little bit about the sources?

S For the Snowmass installation, I went from sixteenth-century madrigals to a contemporary pop song by the Fleet Foxes. It is a song about a winter scene out in the snow, and I just loved the lyrics because the way they follow one another in a kind of loop. "I was following the pack, I was following the pack" repeats over and over. I thought those words would resonate up on Snowmass where you see the people often skiing in packs, one following the other. I thought it's such a fantastic vista of the valley there. I really wanted to encourage people to stop and to take it in. What we've done is installed the speakers in the trees so you're completely immersed in this sound of disembodied voices coming from the trees.

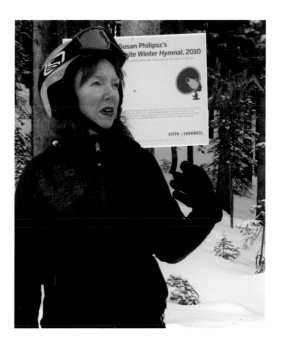

Born in 1965 in Glasgow, Scotland, Susan Philipsz has exhibited widely in the UK and internationally and won Turner Prize 2010 for *Lowlands* (2010). Her solo exhibitions include *When Day Closes*, IHME Project, Pro Arte Foundation, Helsinki (2010); *Lowlands*, Glasgow International (2010); *I See a Darkness*, Tanya Bonakdar Gallery, New York (2010); *You Are Not Alone*, Radcliffe Observatory, Modern Art Oxford, England (2009); and *Out of Bounds: Susan Philipsz*, Institute of Contemporary Arts, London (2008). Her group exhibitions include *Haunted*, Solomon R. Guggenheim Museum, New York (2010); *The Quick and the Dead*, Walker Arts Center, Minneapolis (2009); *Tales of Time and Space*, Folkestone Triennial, Folkestone (2008); *Skulptur Projekte Münster 07*, Germany (2007); and *Days Like These*, Tate Britain Triennial, London (2003).

Lars Ø. Ramberg, *Benchmark*
(Memorial to Hunter S. Thompson), 2010
Installation view, Ajax Mountain, Aspen

WE ALL KNOW WHAT WE KNOW

A July 20, 2011, conversation between Heidi Zuckerman Jacobson, CEO and Director, Chief Curator, Aspen Art Museum, and Mike Kaplan, CEO, Aspen Skiing Company

HEIDI In the eulogy that you wrote for your dad, who passed away recently, you used skiing as a metaphor for life, and I thought that might be a nice way to start our conversation. What does it mean that skiing, something so essential to the Aspen community past, present, and future, is something so multifaceted?

MIKE You know skiing, as a business, is sort of an oxymoron. My grandmother thought, and always reminded me, that the ski business was not a real business. She believed in giving back to society, and for her, that was what work was about.

I think I was challenged by those early statements to find the meaning in skiing and whether or not it was a noble pursuit, a valid life purpose, from a business standpoint. I think I've discovered, during my lifetime, that skiing for me personally, as well as skiing as a business, is much more than a recreational pursuit.

We're talking about art and this connection between art and skiing. Skiing is about self-expression in so many ways. It's a way for me, and I think for many people, to express themselves, to express how they're feeling emotionally and physically. They're communicating in ways that I'd say are even subconscious, that they're not even aware of.

H One of the things you said about skiing in your eulogy is that it's romantic and poetic, and I thought those were interesting terms. I wonder if you could elaborate on these concepts?

M Skiing is romantic in a number of ways. One of the neat things about skiing is that you can share it with others, and you can share it intimately, in a way where it's two people alone together and experiencing something that nobody else can see or feel or understand. Or you can have more random connections, as in a dream, or totally anonymous connections, where you're on the chair lift and you see somebody do something beautiful or funny or stupid.

H Or you talk to someone that you never would have talked to because you're in the gondola for however many minutes together.

M Right. And there's this sort of superficial stuff that was basic, like back in the old days when you called "single" in the lift line to invite other people onto your chair. Everybody would jokingly respond, "Single? Single." or "No, I'm married." There was a funny play on that, typically, going on in the lift line depending on the mood of that lift line or the mountain that day.

For me skiing has always been romantic because I had learned to love the sport under the mentorship of some French ski instructors, who really taught

me about the romanticism of the sport, and particularly its connection with nature. They wouldn't talk as Austrians might saying, "You need to conquer the mountain." The French would say, "You need to make love to the mountain. You need to caress the mountain."

H That's funny.

M There is this feeling that the mountain does have emotions and moods, and if you're looking, they're there. So there is this romance, as I said, with nature, with other strangers, and with people you already love.

H Listening to you talk about skiing and skiing with you gives me a whole different perspective on the sport. On a certain level, people probably think, "Well, yeah, I know how to ski. I know skiing. Skiing is X or skiing is Y." But when you talk to someone who has such a passion about it, you can learn about it in a totally different way. I would make another analogy. I have a friend who's a master sommelier. I drank wine for many years but was not really fascinated by it ever until he once said, "Doesn't it taste like smelly socks?" At first I thought, "Gross." But he made it more accessible and available by talking about wine in terms that are really personal, revealing, and inspiring, and maybe that's what we're doing with art too. People believe they know art and they think, "Well, art's for me" or "Art's not for me." But when you start to put art in front of people in unexpected ways, it shows people that there's so much more to the experience of it than one might originally think.

M I think that's true. What's so engaging, inspiring, and interesting about art are the multiple levels of understanding and emotions that it can evoke in the viewer — and in multiple people viewing together, who can then talk about their shared experience. I always like to say to my son as he's struggling with a sport, "Any sport worth doing is really hard and continues to reveal itself the better you get and the more you discover." I think that is where art is similar to skiing.

What's pretty amazing about Aspen is that whatever people are into here, they're into it at the deepest and most passionate level, where they're really trying to understand it and peel away those layers and get to the bottom of it, if there is really a bottom. They immerse themselves in their interests. They do it in nature and in the mountains, they do it with art, and they do it intellectually. That level of engagement gets you beyond "Oh that's pretty" to "Wow, that's exciting, and I never thought of it that way." That's why it's fun when we talk like this about art, about really trying to look at it and have your own personal reaction. And it is fascinating to have this dialogue about it, and especially to hear from someone like you, who's a curator and has this incredible depth of knowledge. I like that even though the viewer doesn't fully know what the artist was trying to do, they can think "What does the artist want me to say or think or see?" It's impossible to know that, of course, but that's the beauty of it.

H Well, sometimes artists can try and trick you too. They might make you think that a particular work is about one thing as a way of drawing you closer and having you put your guard down, and then that work comes at you from the left, out of a surprising place, and is potentially that much more impactful. So I think the ability to be open to the experience, to embrace the unknown, is where some of the opportunity comes from.

M Do you ever feel like the mountain is trying to trick you?

H Well, I'm not a confident skier. I've been told I'm a much better skier than I think I am, and I think that there's so much in that statement, because it has to do with how we know ourselves, how we see ourselves, and what we identify

as our strengths and weaknesses. I think it's key to sometimes play into our weaknesses. I say about myself that I'm physically not brave but intellectually fierce. But I know that's sort of a cop-out. So I have to think about that for myself when I'm skiing: "Do I want to go down that hill, and if I don't, why don't I? What can I learn from that?" It's the same thing with a work of art. If you don't want to engage with it because you think that the artist may be trying to make fun of you, because you think it's ugly, or because you think anyone could do that—you should ask why you are having that reaction. Art is one of those things that can serve as a reflection of ourselves if we get past our fears and allow it to happen.

M Right. I would argue that it's the same, intellectually or physically. In skiing, the body follows the mind. So obviously in skiing, it's typical intimidation. But again, what is fear or intimidation? They are intellectual feelings, intellectual decisions. So you need to overcome that intellectually and say, "I can engage and focus on what I'm going to do, not what might happen if I don't."

H That's a really key point. I would say that when people don't engage with art, it also comes from a place of fear.

We've talked about the program at the Aspen Institute where you come up with your own moral compass. For those not familiar, the institute was founded by Walter Paepcke in 1950 and features policy programs, conferences, and seminars with leading experts and government officials from around the world. My self-designed moral compass has the idea of transcendence at the top and this idea of fear at the bottom, so that everything you do can be placed somewhere on that vertical line of how close you get to transcendence. The closer you are to transcendence, the further you are from fear; the closer you are to fear, the further you are from transcendence.

M But what is there to be fearful about in art and engaging with art?

H Well, I would say nothing, but I'm comfortable in that space. I would say, for someone who's not comfortable, it's not wanting to be the one person who doesn't get something that everyone else gets. I think that there's often not an "it" to get, but a lot of people want everything put in a really defined box. Art is about getting out of your comfort zone. If people are not comfortable even in their comfort zone for whatever reason—insecurity, self-consciousness, or weakness—then the idea of moving out of that comfort zone is really scary, and that's where the intimidation comes in.

M I think what's scarier for me is to think something is good when nobody else does.

H I think it comes down to trusting oneself and not worrying about how one's own perspective matches up against societal conventions.

M The irony of that to me is, typically, most artists could give a damn what society thinks. Not to overgeneralize artists, but typically they've got a very different sense of self-expression—to the extent that, if you see them walking down the street, you think, "That dude has no fear."

H Sometimes people actually step into that fear. You might find that artists are insecure as people because their vision is so different. Maybe society has pushed them to the edges and so they have a kind of punk sensibility, a defiance that says, "Fine. You've pushed me over here. Then I'm going to stake my ground, and I'm going to give it back to you and make you deal with it." So it's maybe a mistake to think that fearlessness comes from a place of complete confidence and knowledge of self. Often the people who are involved with art find their first community with art—a community of people who have

had different ideas. If people feel challenged to communicate in a traditional way, then perhaps they turn to art for an alternative system of language or dialogue.

M In some ways, you're describing art as a very constructive outlet for people. You are saying that art can play a constructive role in building community.

H I think this goes full circle to your grandmother talking about being a contributing member of the good society. That is for me a justification for my life's work, which is not in some ways so different from yours. I think that what art does, and what's so great about your company's embracing of this philosophy, is that it provides an alternative to whatever people need an alternative to.

I know I've told you the story about my college experience of being in downtown Philadelphia in a romantically induced, semi-distraught state and randomly finding an art gallery. I entered and became so engaged with the objects that when I came back out on the street, I didn't know how much time had passed. I was in a completely different psychological place. Nothing had changed. It wasn't as if what had happened previously hadn't; I still had to go back and address it. But I was in a different place because I had allowed a pause and a moment of reflection to come into my life.

The core idea is to utilize art to break your routine so you can really reflect. Allowing that kind of disruption of the everyday, whether it's inadvertent or advertent, provides a service. You said in skiing it's called "being in the zone."

M Typically, for me, to change my mental state I need to physically do something, to go somewhere special. That's not always available to people. Sure it's easy for me to say "I'm going to go ski up in the Rocky Mountains and change my mental state." But most people don't have that opportunity, even in nearby Glenwood Springs.

H There are so many barriers of entry to things that are actually really good for you. Right? Like the fact that organic food costs more. You have to be somewhere like Aspen to have the experience of skiing on the mountain. You have to buy a ticket and you have to get here if you don't live here. Usually, to go to a museum you have to pay money. What's so great about what we're doing is that we're putting art in the public realm in an undiluted way. Part of the problem with public art is that it is largely done by consensus. Because ours is a partnership, the result of a for-profit and a nonprofit entity coming together, we're not asking permission from a whole bunch of people. So the projects keep their edge. And they're free. The lift tickets aren't free, but everyone is free to look at them. And it is always free to come to the museum.

M Going back to this mental state thing, I think to be in the zone sometimes you have to be a little scared to be totally focused on what you're doing. Some people say, "I like to go on the river and go fishing because I just don't think about anything except being on the river." In a lot of ways, I think the important thing is this opening up of the mind so that you get into "sponge" mode where your defenses are down. Let's say you're skiing and some of this romance comes out. You may be thinking about your next run when you're suddenly taken by the way a glimmer of light hits a mountain peak. That changes your state of mind.

H That's it. That's the possibility of transcendence, right there. Just the way that you described the experience as a combination of the physical, the visual, the psychological, the emotional: an openness to all those things. To me, that's what's exciting about what we're doing, perhaps in contrast to being in a city, going to a museum, paying the money, and walking through. You fork over $15. Your feet hurt. You want a coffee.

Walter Niedermayr,
Aspen Series 10/2009, 2009

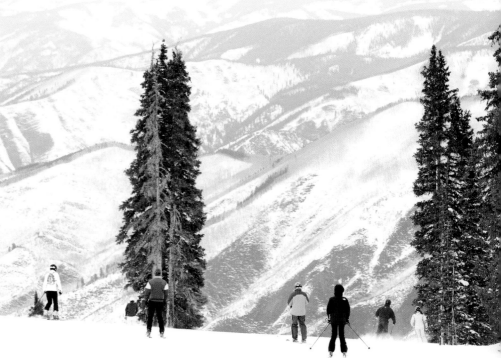

M You find yourself struggling, thinking, "Okay, I'm supposed to get this. Do I get it? Don't I get it? What do other people think?"

H "How long do I have to stay before I can leave?"

M You become focused on insecurity—thinking "Should I get the mobile tour thing to explain this to me?"—versus being in a setting where your defenses are down in a good way, being truly open and absorbing everything. To me, one of the best parts of being in the zone is what happens after.

H Realizing you were there.

M Right. All of a sudden you're seeing things clearly and you have this revelation. It might be something as simple as, "I've got to do this. I've got to connect with this person," or "Now I've got a decision on this thing I've been struggling with forever."

H Even members of our museum team will say, "Hey, I was somewhere and saw work by Jim Hodges," and they notice it because they met Jim when he came out here to do the lift ticket and then saw some of his other work elsewhere. They start to make these connections, almost by accident, and then they start to own those associations and have confidence in them. They start to have more interest in art because their comfort level goes up.

M There's less fear.

H And you're so excited to tell someone because you want them to share your experience. After skiing an amazing run, you might run into someone at the bottom and spontaneously say, "Let's go back up and do it together."

M We talk about progression in skiing, and maybe there's an interesting parallel in art. When you first engage in something, especially skiing, it's overwhelming. "I've got to remember to lean forward, lean to the inside, make sure my hands are out, my head's up, and look ahead." Your head is filled up with these thoughts, so you're just overwhelmed and scared. Then as you stick with it, you start to internalize that stuff and you don't have to think all the time. It becomes automatic. Art at first seems overwhelming, but as you start to make connections between themes or artists or texture or shapes, you start to be able to link them together and no longer have to think, "I don't get it."

H So, when you're not working so hard at it, it becomes really great.

M Right. But you've worked hard to not work hard at it.

H Or you've tried. And that's what I say with the art that we show: it is not about whether people like it or they don't like it, as long as they've given it a chance, a true chance, a good chance. If you've tried and you don't like it, that's okay. But it's not okay to be dismissive.

M Right. Not if you're not trying. It's not okay if you don't like your day skiing. [laughs]

H Well, it is if you're willing to come back and try it again.

M Exactly.

H That's what we say about the museum too. If you don't like what you see, come back again, because every day is different. I think one of the things we're talking around, but not talking at, are the life lessons that come out of what

we're doing. That was the first question I asked you, too. Your reference to skiing in your dad's eulogy is also a metaphor for these lessons: never give up, no excuses, tell the truth, be honest, ask questions . . .

M . . . pick a different line . . .

H . . . try again . . .

M . . . go for it . . .

H . . . don't hold back, and don't let fear stand in your way. And if it doesn't work this time, there's an opportunity to come back to it. With art, there are so many different artists, so many different styles, so many different mediums, that I feel you just can't say, "I don't like art," because art is not just one thing. It can be anything. That's one of the reasons why I like art that takes a nontraditional form, that's made out of everyday materials, or that sits on the floor. That art gives you a heightened awareness of your everyday experiences. It helps you see things differently, and that's a great gift — a real service and contribution to the good society.

M Right. That's ironic, too, because for many people contemporary art is scarier and less accessible on the surface than traditional art. Why?

H Because it's being made now, we don't have the gift of history. With history, you don't have to go out on a limb as much. You don't have to be worried that you're the only one who likes it, because it's been around for a thousand years. It has been canonized and accepted, so you know it's good. You like it, and a ton of other people have liked it too. But if something's being made today or six months ago, there hasn't been the opportunity for enough other people to give their opinion first.

Mamma Andersson at the opening of her Aspen Art Museum exhibition, 2010

M The polling's not complete.

H Right.

M But also, it seems like contemporary art is boundless. Where hundreds of years ago you had traditional media — oil on canvas or sculpture — now you have so many different forms of art. To me it's a reflection of our digital age, where you don't have as many borders and clear definitions. It's a scary thing about living today, but it's also an exciting thing.

H We are living in an unprecedented time, with unprecedented access to information and physical mobility. You can communicate with people you've never met on all different parts of the planet. You can move yourself, if you have the means, from one place to another in a short amount of time. Look at gay marriage. This is happening in our time, in our space, and it's so exciting. But it's so threatening to so many people because it's such a massive change.

M Right. It's happening in skiing too. Areas that were natural barriers between runs, where you wouldn't think to put a rope or a closure sign, now need to be marked because of new equipment and the new mentality that anything and everything is skiable. It extends beyond any boundary. It's amazing how this is a societal trend.

H Yeah. It's a zeitgeist.

M It pushes into art, skiing, and everything we do.

H All the boundaries are gone. That's exciting, but it's also really dangerous, particularly what you're talking about.

M Right. People are more on the edge than ever before.

H It's funny. Some people want routine, consistency, and others are seekers. In general, I would say that people who are skiing are seeking something, whether it's the romance or the exhilaration or the conquering of intimidation. I would say the same thing about people who are willing to look at art. They're open to see something that's new, that's challenging, that could be dangerous in some way, shape, or form, and that's what's so exciting about it.

M As you were talking, I was thinking about this relationship between art and the ski business. When you get back to the business side of things, this relationship is about being on the edge. We've experienced that a lot where the lift-ticket project is providing art in unexpected places, something that you brought on to the scene under the radar.

H I did. I was surprised when you guys said yes.

M Snuck it in there. I don't even remember that being a deliberate decision. We've talked about this over the years. You've continued to push us and we've continued by pushing the envelope on this connection between art and skiing as it's presented on the lift ticket, which is a very core aspect of the most rational part of the business: the transaction of "you give me money, I give you this piece of paper." We've struggled with what the person expects visually and emotionally and logically. We've talked about how we've moved from the typical, "We're going to give you this piece of paper that has a nice picture of a person skiing powder."

Maybe the first and biggest push away from that model was when we went to Jim Hodges's text-based art for the lift ticket. It says, "Give more than you

Mike Kaplan, Heidi Zuckerman Jacobson, former Aspen Skiing Company Vice President of Marketing Jeanne Mackowski, and artist Jim Hodges (left to right) at the opening of his Aspen Art Museum exhibition, *you will see these things*, 2009

take." After I've just given you a hundred or so dollars and you're giving me this ticket that says, "Give more than you take," customers might ask themselves "Why?" I guess I would like to ask you that question. Why should we do that, and why do you think it makes sense?

H I think the idea of asking a question is so important. "How did this happen? How did art get put on the lift ticket?" For me, it was first noticing what I would call an absence or a gap while looking at these tickets. When I came here to ski and saw a generic alpine landscape on them, I thought "that doesn't speak Aspen." I've had that same image on my ticket when I've skied in New York or California. So I simply asked "Why is it like this?" Sometimes things start with the simplest questions, like "Can we do this differently?" My answer to the customer would be that Aspen isn't like everywhere else. So why should anything that we do be the same as anywhere else? It should be the best, the most interesting, and the most dynamic. If that's what people actually expect of Aspen, then when you don't do that, it stands out.

M Why push us to take the risk of having the customer say, "I don't get it?"

H I don't think that people say, "I don't get it." It's not a conscious decision to not get it. If the transaction starts with the lift ticket, which is the dispersal of funds, and then the receipt of this object, let's think about the ticket as an object with multiple values. One of the values is it gets you through the turnstiles. Another value is that it reminds you where you are. Another value reminds you of what you're doing.

M And when you go home, it reminds you what you've done. It serves as a memory.

H A memento. From a business standpoint, I think what you're trying to do

for people is to say, "This is more than you expect." You expect to be handed something, but you don't expect it to look different or beautiful or surprising. I don't think it's about, "I get it or I don't get it." I think it's saying, "Welcome. Here's something that's more than you expected. A bonus of sorts."

M The other benefit of pushing the envelope on the art we're presenting on the lift ticket is that it creates more opportunity for dialogue, discussion, and engagement. That doesn't happen enough in society, in social settings, in a meaningful way, beyond the cocktail talk of "How are you doing? Where was your last vacation?" We've shifted that dialogue to "What is this? What does that mean to give more than you take?" Now that dialogue can happen with an employee, with our ticket seller, or a lift operator, which is something that for me is a business goal. How do you build loyalty to a resort? You establish a relationship and emotional connection with each and every guest. To have them actually look at art and talk about art, that's really an opportunity to engage in a way that is unexpected and creates a stronger, lasting connection. It also starts dialogue with friends, family, or a stranger on the chairlift or in the restaurant.

H When I came to show you the Jim Hodges idea I said, "This is an opportunity for you guys to look at yourself. Do you actually give more than you take in a truly comprehensive and profound way? Can you stand for that?" That, I think, gets back to some of these essential questions. "What do you stand for? As a resort? What do you stand for as a company? What do we stand for as a town? Do we give more than we take?" There is some of the Buddhist idea, "Leave no trace."

M I think the core values of this community align here with the company and the people that work with us. So I suppose the eternal question is, "Are you willing to take risks and to push yourself in every way and to embrace different perspectives?"

H I actually want people to give of themselves so that they can take something away. What do they have to give? An openness, a willingness to engage, to go for it, to jump in. What do they take? The experience, the opportunity, the transcendence, and the dialogue.

M And then where do they take it?

H And to whom do they give it?

Yutaka Sone: *X-Art Show*
Installation view, Aspen Art Museum, 2006

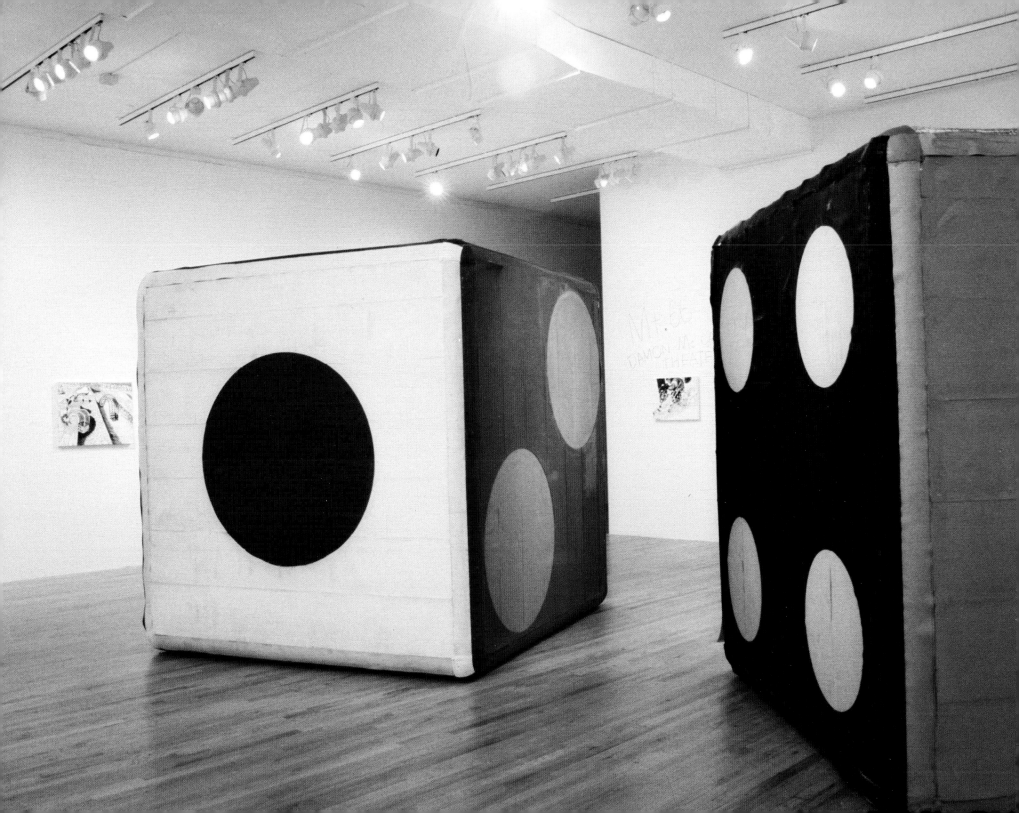

THE CROWN FAMILY

ASPEN SKIING COMPANY

STAFF

Heidi Zuckerman Jacobson,
Chief Executive Officer and
Director, Chief Curator

John Barker
Leslie Bixel
Sherry Black
Kelly Carver
Ellie Closuit
Genna Collins
Jonathan Hagman
Annie Henninger
Jason Hurley
Karen Johnsen
Nicole Kinsler

Sallie Klein
Jeff Murcko
Grace Nims
Mike O'Connor
Jacob Proctor
Jared Rippy
Rachel Rippy
Liza Rueckert
John-Paul Schaefer
Jennifer Schneider
Ryan Shafer
Danielle Stephens
Matthew Thompson
Karl Wolfgang
Luis Yllanes

Mike Kaplan, *President/Chief Executive Officer*

David Bellack
Rich Burkley
David Corbin
Susan Cross
Deric Gunshor
Kevin Hagerty
Matt Jones
Peter King
Christian Knapp
Jim Laing
Natasha Lucero
Jeanne Mackowski
Ryan Miller
David Perry
John Rigney
Jodi Roy
Rachel Schaefer
Auden Schendler
Don Schuster
Steve Sewell
Lea Tucker
Jim Ward

LIST OF ILLUSTRATIONS

Cover, pp. 1–6: Yutaka Sone, *Mt. 66*, 2006. Performance at Buttermilk Mountain, Aspen. Photos: Daniel Bayer.

p. 8: Aspen (Ajax) Mountain. Photo: Daniel Bayer. Image courtesy Aspen Skiing Company.

p. 10: Jim Hodges, *give three times*, 2009. Installation view, Aspen Art Museum.

p. 12: Gondola on Ajax Mountain, Aspen. Photo: Daniel Bayer. Image courtesy Aspen Skiing Company.

p. 15: Patterson Beckwith at the 2009 Bud Light Spring Jam. Photo: Jeremy Swanson. Image courtesy Aspen Skiing Company.

pp. 16–17: Patterson Beckwith, *Portrait Studio*, 2009. Stills from Polaroid positive/negative film. Courtesy the artist.

p. 18: Jennifer West, *Shred the Gnar Full Moon Film Noir*, 2010. Production still. Photo: Jennifer West. Image courtesy the artist.

p. 19: Yutaka Sone, *Mt. 66*, 2006. Performance at Buttermilk Mountain, Aspen. Photo: Daniel Bayer.

pp. 20–21: Susan Philipsz, *White Winter Hymnal*, 2010. Installation views, Trestle Bridge, Snowmass. Photos: Jeremy Swanson. Image courtesy Aspen Skiing Company.

pp. 23: Walter Niedermayr, *Aspen Series 32/2009*, 2009. Color, diptych. 51 5/8 x 83 1/8 inches. Courtesy Aspen Skiing Company; Galerie Nordenhake, Berlin | Stockholm; Galleria Suzy Shammah, Milan; Robert Miller Gallery, New York

p. 25, left: Yutaka Sone, *X-Games Site Model #2*, 2005. Wood, foam, and acrylic paint. 24 x 42 x 17 inches. Courtesy of the artist and David Zwirner, New York. Photo: Steve Mundinger.

p. 25, right: Yutaka Sone, *X-Games Site Model #1*, 2005. Wood, foam, and acrylic paint. 24 x 39 x 45 inches. Courtesy of the artist and David Zwirner, New York. Photo: Steve Mundinger.

p. 26: Karen Kilimnik, *Switzerland, the Pink Panther & Peter Sellars & Boris & Natasha & Gelsey Kirkland in Siberia*, 1991. Mixed media. Dimensions variable. Courtesy 303 Gallery, New York.

p. 27: Peter Doig, *Olin MK IV*, 1995. Oil on canvas. 98 1/2 x 78 3/4 inches. Courtesy Gavin Brown's Enterprise, New York.

p. 28: Carla Klein, *Untitled*, 2009. Oil on cotton. 12 x 27 1/2 inches. Courtesy of the artist and Tanya Bonakdar Gallery.

p. 29: 2010–11 lift ticket featuring Mamma Andersson, *Sleeping Standing Up*, 2003. Image courtesy Galleri Magnus Karlsson, Stockholm; David Zwirner, New York; and Stephen Friedman, London. Copyright the artist.

p. 30: Walter Niedermayr, *Aspen Series 34/2009*. Color, triptych. 51 5/8 x 125 1/4 inches. Courtesy Aspen Skiing Company; Galerie Nordenhake, Berlin | Stockholm; Galleria Suzy Shammah, Milan; Robert Miller Gallery, New York.

p. 32, inset: Yutaka Sone, *Mt. 66*, 2006. Performance at Buttermilk Mountain, Aspen. Photo: Daniel Bayer.

p. 33, top: 2005–06 lift ticket featuring Yutaka Sone, *Ski Madonna (#1)*, 2005. Acrylic on canvas. 36 x 24 inches. Courtesy of the artist and David Zwirner, New York.

p. 33, bottom: Live Graffiti at the 2006 Bud Light Spring Jam, Aspen. Photos: Jeremy Swanson. Images courtesy Aspen Skiing Company.

p. 35, top: 2006–07 lift ticket featuring Peter Doig, *Untitled*, 2006. Oil on paper. 27 x 20 inches. Courtesy Gavin Brown's Enterprise, New York.

p. 35, bottom: Assume Vivid Astro Focus at the 2007 Bud Light Spring Jam, Aspen. Photos: Jeremy Swanson. Images courtesy Aspen Skiing Company.

p. 36, bottom: Psychedelic films at the 2008 Bud Light Spring Jam, Aspen. Photo: Jeremy Swanson. Image courtesy Aspen Skiing Company.

p. 37, top: 2007–08 lift ticket featuring Karen Kilimnik, *Gelsey Stuck on the Matterhorn*, 2000. Water-soluble oil color on canvas. 20 x 16 inches. Courtesy the artist and 303 Gallery, New York.

p. 37, bottom: Create Your Own Lift Ticket workshop at Buttermilk Mountain, Aspen, 2008.

p. 39, top: 2008–09 lift ticket featuring Jim Hodges, *Give More Than You Take*, 2008. Image courtesy of the artist.

p. 39, bottom: Patterson Beckwith at the 2009 Bud Light Spring Jam, Aspen and Snowmass. Photos: Jeremy Swanson. Images courtesy Aspen Skiing Company.

p. 40, bottom: Create Your Own Lift Ticket workshop at Snowmass, 2010.

p. 41, bottom right: Jennifer West, *Shred the Gnar Full Moon Film Noir*, 2010. Screening at the 2010 Bud Light Spring Jam, Aspen. Photo: Jeremy Swanson.

p. 41, top: 2009–10 lift ticket featuring Carla Klein, *Untitled*, 2009. Oil on cotton. 12 x 27 1/2 in. Courtesy of the artist and Tanya Bonakdar Gallery, New York.

p. 41, bottom left: Jennifer West, *Shred the Gnar Full Moon Film Noir*, 2010. Production still. Photo: Jennifer West. Image courtesy the artist.

p. 41, bottom right: Jennifer West, *Shred the Gnar Full Moon Film Noir*, 2010. Screening at the 2010 Bud Light Spring Jam, Aspen. Photo: Jeremy Swanson.

p. 42, top: 2010–11 season pass featuring Walter Niedermayr, *Aspen Series 72/2009*, 2009. Color triptych. 51 5/8 x 125 1/4 inches. Courtesy Aspen Skiing Company; Galerie Nordenhake, Berlin | Stockholm; Galleria Suzy Shammah, Milan; Robert Miller Gallery, New York.

p. 42, bottom left: Susan Philipsz, *White Winter Hymnal*, 2010. Installation view, Trestle Bridge, Snowmass. Photos: Jeremy Swanson. Image courtesy Aspen Skiing Company.

p. 42, bottom center: Create Your Own Lift Ticket workshop at Snowmass, 2011.

p. 42, bottom right: David Benjamin Sherry at the 2011 Bud Light Spring Jam, Aspen. Photo: Jeremy Swanson. Image courtesy Aspen Skiing Company.

p. 43, top: 2010–11 lift ticket featuring Mamma Andersson, *Sleeping Standing Up*, 2003. Image courtesy Galleri Magnus Karlsson, Stockholm; David Zwirner, New York; and Stephen Friedman, London. Copyright the artist.

p. 43, bottom: Installation view of Mark Wallinger, *Amerika*, 2010 (left) and Lars Ø. Ramberg, Benchmark (Memorial to Hunter S. Thompson), 2010 (right). Photos: Jason Dewey.

p. 44: Highland Bowl, Aspen Highlands. Photo: Daniel Bayer. Image courtesy Aspen Skiing Company.

p. 48: Yutaka Sone, *Ski Madonna (#1)*, 2005. Acrylic on canvas. 36 x 24 inches. Courtesy of the artist and David Zwirner, New York.

p. 49: 2005–06 lift ticket featuring Yutaka Sone, *Ski Madonna (#1)*, 2005.

p. 50: Yutaka Sone, *Dice, Storyboard*, 2005. Acrylic on canvas. 24 x 36 inches. Courtesy of the artist and David Zwirner, New York.

p. 51: Yutaka Sone, *Dice, X-Games*, 2005. Acrylic on canvas. 24 x 30 inches. Courtesy of the artist and David Zwirner, New York.

p. 53: Yutaka Sone. Photo: Daniel Bayer.

pp. 54–55: Yutaka Sone: *X-Art Show*. Installation views, Aspen Art Museum, 2006. Photos: Chuck Curry.

p. 58: Peter Doig, Study for *Olin Mark IV*, 1996. Oil on canvas. Courtesy Gavin Brown's Enterprise, New York.

p. 59: 2006–07 lift ticket featuring Peter Doig, *Study for Olin Mark IV*, 1996.

p. 60: Peter Doig, *Untitled*, 2006. Oil on paper. 27 x 20 inches.

p. 61: Peter Doig, *Figure in Mountain Landscape*, 1997–98. Oil on canvas. 113 3/4 x 78 1/2 inches. Private collection, London. Image courtesy Victoria Miro Gallery.

p. 63: Karen Kilimnik, *The Matterhorn at night, dreamland, 9pm, 3am, Zermatt*, 2007. Hand-printed lithograph on inkjet print with hand-applied glitter. Edition of 75. 22 x 18 3/4 inches unframed. Courtesy the artist and 303 Gallery, New York.

p. 64: Karen Kilimnik, *Gelsey Stuck on the Matterhorn*, 2000. Water-soluble oil color on canvas. 20 x 16 inches. Courtesy the artist and 303 Gallery, New York.

p. 65: 2007–08 lift ticket featuring Karen Kilimnik, *Gelsey Stuck on the Matterhorn*, 2000.

pp. 66–67: Karen Kilimnik (exhibition). Installation views, Aspen Art Museum, 2008. Photos: Karl Wolfgang

p. 70: Jim Hodges, *Give More Than You Take*, 2008. Image courtesy of the artist.

p. 71: 2008–09 lift ticket featuring Jim Hodges, *Give More Than You Take*, 2008.

pp. 72–73: Jim Hodges: *you will see these things*. Installation views, Aspen Art Museum, 2009. Photos: Karl Wolfgang.

p. 75, top: Carla Klein and Leon Duenk skiing in Aspen. Image courtesy the artist.

p. 75, bottom: Studies for the 2009–10 lift ticket in the artist's studio. Photo: Carla Klein. Image courtesy the artist.

p. 76: Carla Klein, *Untitled*, 2009. Oil on cotton. 12 x 27 1/2 in. Courtesy of the artist and Tanya Bonakdar Gallery, New York.

p. 77: 2009–10 lift ticket featuring Carla Klein, *Untitled*, 2009.

p. 78. Carla Klein's journey to Aspen. Photos: Carla Klein. Images courtesy the artist.

p. 79: Carla Klein at the Create Your Own Lift Ticket workshop at Snowmass, 2010.

p. 81: Jennifer West, *Shred the Gnar Full Moon Film Noir* (filmstrip), 2010. Image courtesy MARC FOXX, Los Angeles.

p. 82: *Shred the Gnar Full Moon Film Noir* production stills at Kick Aspen Big Air, Aspen Mountain, 2010. Photos: Mariah Csepanyi (top left, lower right) and Jonathan Hagman. Images courtesy of the artist.

p. 83: *Shred the Gnar Full Moon Film Noir* production stills at Fallen Friends, Aspen Highlands, 2010. Photos: Jennifer West and Jonathan Hagman (lower right).

p. 88: Mark Wallinger, *Amerika*, 2010. Vinyl billboard. 128 x 192 inches. Courtesy of the artist and Anthony Reynolds Gallery, London. Image of Aspen courtesy Daniel Bayer.

pp. 89, 91: Mark Wallinger, *Amerika*, 2010. Installation views, Aspen. Photo: Jason Dewey.

p. 94: Lars Ø. Ramberg. *Benchmark (Memorial to Hunter S. Thompson)*, 2010. Spruce bench with gold leaf inlay. Approximately 36 x 70 x 30 inches. Courtesy of the artist. Installation view in Aspen. Photo: Jason Dewey.

p. 95: Lars Ø. Ramberg. *Benchmark (Memorial to Hunter S. Thompson)*, 2010. Spruce bench with gold leaf inlay. Approximately 36 x 70 x 30 inches. Courtesy of the artist. Installation view in on Ajax Mountain (p. 95). Photo: Jason Dewey.

p. 98: Walter Niedermayr, *Aspen Series 72/2009*, 2009. Color, triptych. 51 5/8 x 125 1/4 inches. Courtesy Aspen Skiing Company; Galerie Nordenhake, Berlin | Stockholm; Galleria Suzy Shammah, Milan; Robert Miller Gallery, New York.

p. 99: 2010–11 season pass featuring Walter Niedermayr, *Aspen Series 72/2009*, 2009.

p. 100: Walter Niedermayr, *Aspen Series 77/2009*, 2009. Black-and-white, diptych. 51 5/8 x 83 1/8 inches. Courtesy Aspen Skiing Company; Galerie Nordenhake, Berlin | Stockholm; Galleria Suzy Shammah, Milan; Robert Miller Gallery, New York.

p. 101: 2010–11 season pass featuring Walter Niedermayr, *Aspen Series 77/2009, 2009.*

p. 103: Walter Niedermayr, *Aspen Series 25/2009*, 2009. Black-and-white, diptych. 51 5/8 x 83 1/8 inches. Courtesy Aspen Skiing Company; Galerie Nordenhake, Berlin | Stockholm; Galleria Suzy Shammah, Milan; Robert Miller Gallery, New York.

p. 106: Mamma Andersson, *Sleeping Standing Up*, 2003. Oil on panel. 35 1/2 x 48 1/8 inches. Skeppner Collection. Courtesy Galleri Magnus Karlsson, Stockholm; David Zwirner, New York; and Stephen Friedman, London. Copyright the artist.

p. 107: 2010–11 lift ticket featuring Mamma Andersson, *Sleeping Standing Up*, 2003.

pp. 108–09: Mamma Andersson (exhibition). Installation views, Aspen Art Museum, 2010. Photos: Karl Wolfgang.

pp. 112–115: Susan Philipsz, *White Winter Hymnal*, 2010. Installation views, Trestle Bridge, Snowmass. Photos: Jeremy Swanson.

p. 117: Susan Philipsz. Photo: Jeremy Swanson.

p. 118: Lars Ø. Ramberg, *Benchmark (Memorial to Hunter S. Thompson)*, 2010. Spruce bench with gold leaf inlay. Approximately 36 x 70 x 30 inches. Courtesy of the artist. Installation view, Ajax Mountain, Aspen. Photo: Jason Dewey.

p. 123: Walter Niedermayr, *Aspen Series 10/2009*, 2009. Color, diptych. 51 5/8 x 83 1/8 inches. Courtesy Aspen Skiing Company; Galerie Nordenhake, Berlin | Stockholm; Galleria Suzy Shammah, Milan; Robert Miller Gallery, New York.

p. 125: Mamma Andersson at the opening of her Aspen Art Museum exhibition, 2010.

p. 127: Aspen Skiing Company CEO Mike Kaplan; Aspen Art Museum CEO and Director, Chief Curator, Heidi Zuckerman Jacobson; former Aspen Skiing Company Vice President of Marketing Jeanne Mackowski; and artist Jim Hodges (left to right) at the opening of his Aspen Art Museum exhibition, *you will see these things*, 2009.

p. 129: Yutaka Sone: *X-Art Show*. Installation view, Aspen Art Museum, 2006. Photos: Chuck Curry.

Published by Aspen Art Press and The Crown Family

ASPEN ART MUSEUM

590 North Mill Street, Aspen, CO, 81611
United States
aspenartmuseum.org

THE CROWN FAMILY

222 North LaSalle Street
Suite 2000
Chicago, Illinois 60601
United States

A CIP record for this book is available from the Library of Congress.
ISBN 978-0-934324-54-0

Edited by Ryan Shafer
Catalogue design by Miko McGinty, Inc.
Printed by Global Interprint, Inc., Santa Rosa, California
Printed and bound in China

Available through Artbook, LLC and D.A.P. | Distributed Art Publishers
155 Sixth Avenue, 2nd Floor, New York, N.Y., 10013
Tel: (212) 627-1999
Fax: (212) 627-9484

Aspen Art Museum exhibitions and artist projects are funded in part by the
AAM National Council. General exhibition support is provided by The Andy
Warhol Foundation for the Visual Arts. Exhibition lectures are presented as
part of the Questrom Lecture Series.